IMAGES
of America

CLIFTON

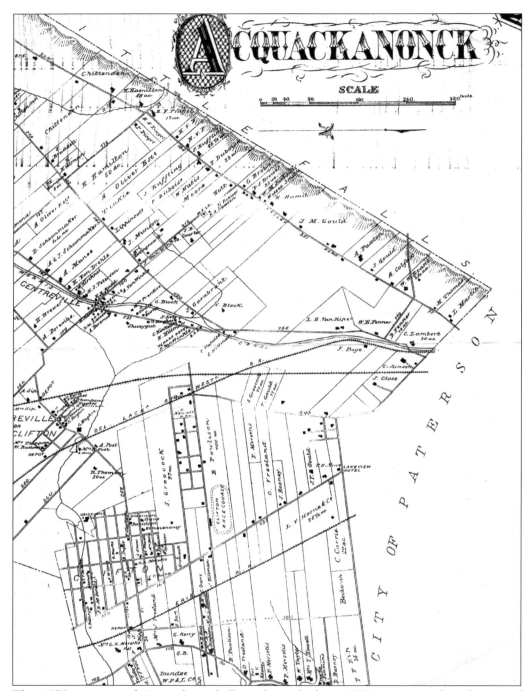

This 1870s-era map of Acquackanonk Township, which in 1917 incorporated as the city of Clifton, shows its border with Little Falls across the top. Near the top left is seen the property of Chittenden, today marked by a road of that name. Follow Valley Road into Albion toward Paterson and you get to the 30-acre property of C. Lambert, whose Lambert Castle had not yet been built. Note the location of the Clifton Racetrack midway down the map.

2

IMAGES
of America

CLIFTON

Philip M. Read

ARCADIA

First printed in 2001.

Published by Arcadia Publishing,
an imprint of Tempus Publishing, Inc.
2A Cumberland Street
Charleston, SC 29401

Printed in Great Britain.

Library of Congress Catalog Card Number: 2001091402

For all general information contact Arcadia Publishing at:
Telephone 843-853-2070
Fax 843-853-0044
E-Mail sales@arcadiapublishing.com

For customer service and orders:
Toll-Free 1-888-313-2665

Visit us on the internet at http://www.arcadiapublishing.com

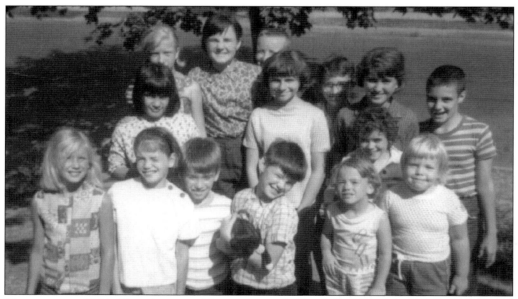

The year was 1964. The place was Harrington and Woods End Roads in Clifton's Allwood section, which boasted a true postwar tract of Cape Cod and ranch-style houses. It was also the height of the baby boom. How else could you get 15 kids in a picture without even having a party? There is Bill Read, with a stray cat dubbed "Snowball," and younger brother, Phil Read, to his right. Also there is Debbie Daves (front row, far left), who lived a few doors down; then, Dorian Flint (middle row, far left) and her brother Ross Flint (middle row, far right), who lived next door. With the rapid pace of postwar development, Clifton's 12 square miles were well prepared to handle the abundance of children. As the population grew, graduating classes broke the 1,000 mark.

CONTENTS

This work is dedicated to my father, William Marsden Read III, one of Maywood's own who made Clifton his home and who passed away during the preparation of this history.

ACKNOWLEDGMENTS

There are certain people whose contributions made this pictorial work possible. As such, words of thanks go to Dorothy Van Dillon, the widow of the "Last Great Athenian," historian David Van Dillon, for access to her husband's extensive collection; Mark S. Auerbach, the Passaic City historian, for access to his sizable collection of Clifton postcards and for his words of encouragement; Dale Bedford, research librarian, for her patience during the scanning of offerings from the Clifton Memorial Library's Local History Room, as well as to executive director Christine Zembecki and the Clifton Library Board of Trustees; Thomas A. Hawrylko Sr., publisher of Clifton Merchant Magazine, for his contributions to furthering Clifton's history; the Clifton Historical Commission, whose chairman, Jack Kuepfer, freely offered his blessing to this former commissioner; Andrew Shick, executive director of the Passaic County Historical Society, for his help in accessing the society's Clifton selections; and the good people of Clifton, whose friendliness and cooperativeness is without comparison.

INTRODUCTION

In the early years of the last century, Clifton was a destination point. "EVERYBODY IS TALKING ABOUT CLIFTON," read the heading of a real-estate advertisement in the *Passaic Daily News* in 1909. "What a pretty place it is and how much prettier it will be when Main Avenue is asphalted. Clifton will then be the Broadway of the county. Now is the time to buy lots or houses, for it is an assured fact that the Erie is to have electric trains through the McAdoo [Holland] tunnels, and when that time arrives, prices of real estate will be much higher."

Clifton was big by the standard of the day: a full 12 square miles. Its proximity to New York City made it a magnet. What if a place could be found where there was natural beauty, convenience to business, and good neighbors? "Of all the villages within 20 miles of New York," said a pamphlet of the Clifton Land and Building Association, "none combine the above attractions more completely than Clifton."

However, it was the post–World War II boom that altered Clifton, as it did much of suburban America. On July 9, 1948, a newspaper headline announced "1,329 permits for one-family homes issued since end of war." An extra 88 were issued for two-family homes. "The completion of Route S-3 from Clifton to the Lincoln Tunnel, scheduled for the end of the year, is expected to add further impetus to the building boom. The new highway will make 20-minute trips from Clifton to Manhattan a reality," said the article.

The baby boom was in full swing. Parks were created and schools were built. Clifton High School, which in the 1970s was named one of the 100 Best High Schools in the country by Tulane University, became the second-largest high school in New Jersey. With it came the advantages of size: a large pool of boys to produce winning football teams and a bumper crow of advanced placement classes that smaller districts simply could not offer. This was, after all, always a place with children at heart.

Babe Ruth played here. So did the Yankees. In the days when blue laws forbade baseball games in major-league cities, teams played at Clifton's Doherty Oval, home of the Doherty Silk Sox. The Silk Sox even managed to defeat the mighty Yankees. Though it operated only a few short years, Fairyland Amusement Park was a big draw. Rudy Vallee, the crooner whose hits included "My Time Is Your Time," paid a visit to the Allwood section manufacturer of hair cream and Scott's Emulsion in May 1956. Frankie Randall, star of the 1960s classic *Wild on the Beach,* called Clifton home.

It all started with an intriguing election in 1917. The Home Rule League, made up of Acquackanonk Township citizens opposed to incorporation as a city, hired detectives, who declared they had found "padding" of voter registration lists. "Allege 85 illegal voters in one ward," read one newspaper headline. A committeeman replied: "I brand that as a downright, outrageous, scurrilous lie. The members of this board have lived among you for a number of years. You know them as honest young men, and I hope you will resent these attacks."

Come election day, April 24, 1917, the league's hired detectives were barred from coming within 100 feet of the polling places. Taverns were closed. "The township is as dry as the Sahara Desert today," read an account of that day. "People accustomed to their morning 'nip' were compelled to rise before 6 o'clock. When the polling places opened, the inns and taverns were closed up tight."

In those first hours, more votes were cast than at any special election ever.

The next day, the people of Allwood, Richfield, Delawanna, and Albion Place found themselves in the Clifton fold, even though their ward had opposed it. Now, they would be linked with Lakeview and Lakeview Heights, where the "yes" vote prevailed because of fears of being annexed to Paterson. Also joined now were Athenia and the village of Clifton under the city's new banner.

One writer championed, "It has outgrown its swaddling clothes, reached the stature of manhood and should be garbed as a full-fledged man."

On the night of April 25, 1917, at a meeting opened by Mayor Clarence W. Finkle at Clifton High School, international events quickly overtook the vote creating Clifton just a day earlier. Now, the town's 24,000 people shifted their attention a world away. "Enthusiastic audience at fine patriotic meeting/National anthems are sung—Mr. Gourley Delivers Address Urging Conscription" read the headline in the *Passaic Daily News*.

William B. Gourley, a champion of incorporation, gave what a newspaper reporter deemed "one of the finest patriotic talks ever given Clifton," though the turnout of 150 men and women was less than hoped for. Still, they sang. Standing, the crowd sang the "Star-Spangled Banner." Phoebe Cox sang "America, I've raised my boy for you," in a number that took the house by storm, and followed up with "Let's All Be Americans Now."

"A couple days ago," Gourley said, "we tried to wake up Acquackanonk. It should now be 'Wake Up Clifton.' The country is at war. We are asleep," he said, citing the loss of American lives and the sinking of U.S. ships by Germany.

This was a place of ordinary people, too. As Mayor Finkle gave a speech at a flag-raising ceremony in Albion, a dozen stray children were brought to police headquarters after the fine weather gave them a case of wanderlust. Other children playing on East Clifton Avenue set fire to a tree. The next day, Clifton's mayor and council officially met for the first time.

One

PLACES TO GO,
PEOPLE TO SEE

*We pay tribute today to your boys, our boys, patriots all marching shoulder
to shoulder, the marine, sailor, nurse, and aviator. No more hyphens,
no more Italian-Americans, Russian-Americans, Polish-Americans. They are all
marching together, along the same road that leads to the
one place, and that place is "Victory."*

—Mayor William E. Dewey, October 25, 1942

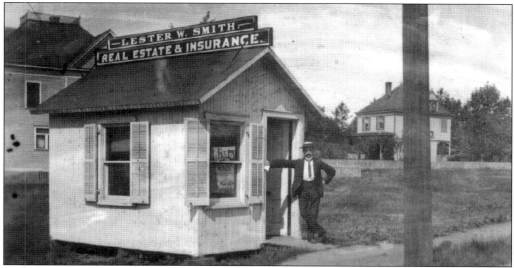

In 1900, the crossroads of Main and Clifton Avenues, which is downtown today, housed the small office of Lester W. Smith, a seller of real estate and insurance, on its northwest corner. In 1905, according to a newspaper account, Smith "decorated his building by having it painted a bright yellow, with white trimmings and green shutters." The house behind the cabin is used today as offices of the United Reformed Church of Clifton. For many years, the corner was home to McHenry's Drugs. (Courtesy of Clifton Memorial Library.)

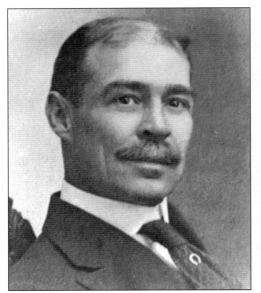

Clarence W. Finkle Sr. (left), chairman of the Acquackanonk Township Committee, became mayor with the incorporation on April 26, 1917, and served until January 1, 1918, when George F. Schmidt (right) officially became Clifton's first elected mayor. (Courtesy of the Clifton Public Library.)

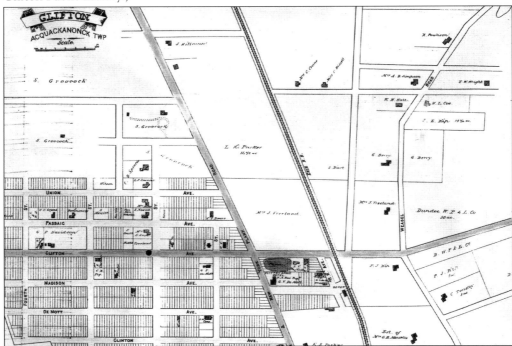

This atlas map of the village of Clifton, township of Acquackanonk, dates from 1877 and shows the DeMott house near the corner of Madison Avenue and First Street. The house, which still stands, served as the library briefly in the 1940s. At the time, there was a swimming hole behind the old Clifton Theater.

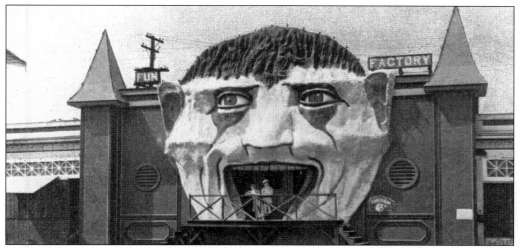

Fairyland put Clifton on the map in 1905, though an advertisement touting the amusement park's arrival pinpointed its location as "midway between Paterson and Passaic, N.J." This c. 1908 postcard beckons thrill-seekers to the Fun Factory. (Courtesy of the Van Dillon and Mark S. Auerbach Collections.)

FAIRYLAND

Midway between Paterson and Passaic, N. J.

A RESPECTABLE PLACE FOR RESPECTABLE PEOPLE
OPENING SATURDAY, MAY 27TH.

Two daily performances of the World's best Vaudeville, continued outdoors with

A Free Sensational Performance

FREE } Band Concerts
Colored Plantation Singers

NEW JERSEY'S BEST DANCING PAVILION.
15,000 Electric Lights.

All Public Service Trolley lines transfer to FAIRYLAND.
OR ERIE RAILROAD TO LAKEVIEW STATION.
MELVILLE & SCHULTHEISER.

Just days from opening, this is how Fairyland promoted its forthcoming opening in a May 24, 1905f newspaper advertisement. In a newspaper story, a reporter had this to say about the park's advent: "The ground will be replete with attractions, but there will be nothing repulsive in the entire enclosure. Neither will rowdyism be countenanced by the management. The place will be maintained only for respectable people."

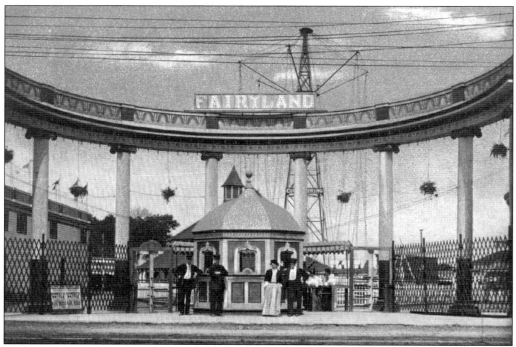

Clifton's gateway to amusement, the entrance to Fairyland (above), stood at the site of today's Corrado's Market, on Main Avenue. "CROWDS AT FAIRYLAND," shouted a headline after the park opened. Nearly 15,000 people turned out and saw the view inside (below). "Pretty Fairyland girls in blue and gold handled tickets until their fingers ached," said an article, "but the crush at the main gates continued until 10 p.m." (Courtesy of the Van Dillon and Mark S. Auerbach Collections.)

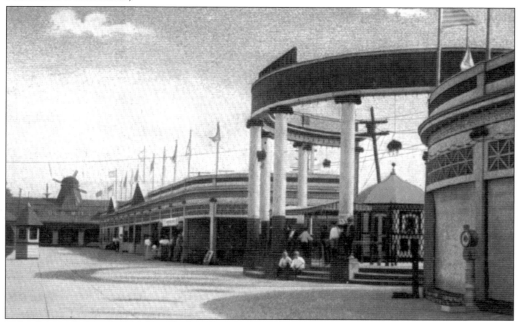

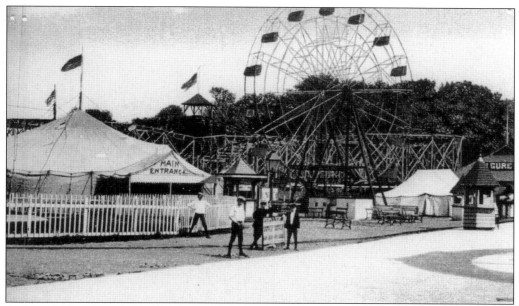

An insider's view of Fairyland included the Ferris wheel and circus tent. "An immense Ferris wheel brightly illuminated will occupy the center of the grounds, while fully a dozen other new amusement features are being arranged for," said a newspaper report. The fun included the Cave of the Winds, the House of Laughter, and the rides Razzle Dazzle and Down and Out. The fun, however, lasted four short years. (Courtesy of the Van Dillon and Mark S. Auerbach Collections.)

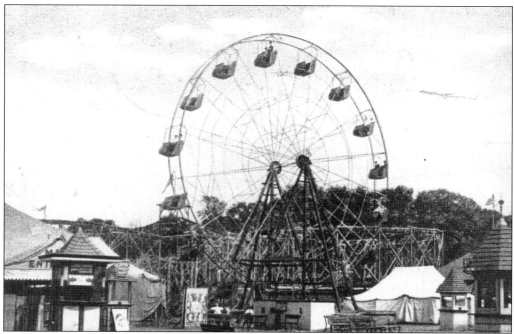

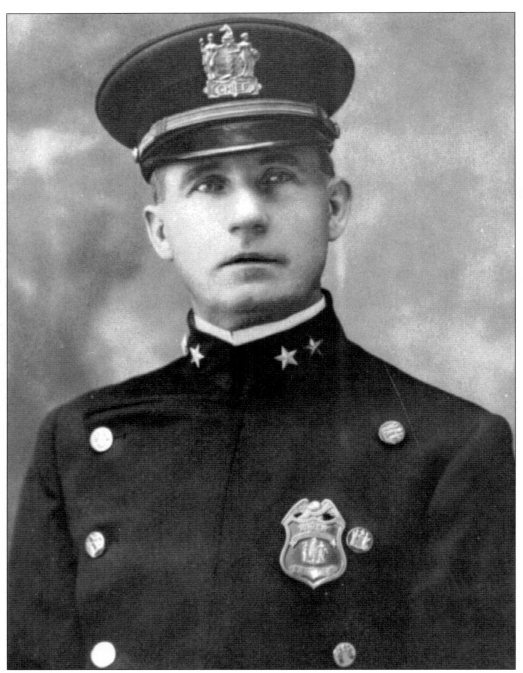

William J. Coughlan, Clifton's first police chief, was the chief constable appointed to keep the peace at Fairyland during its 1905 opening. On the night he was appointed, the Acquackanonk Township Committee apparently had little patience with a move to bar the amusement park's opening. "A protest against the licensing of the Fairyland Amusement Park was received, read and on motion ordered filed," read an account of the meeting. (Courtesy of the Clifton Public Library.)

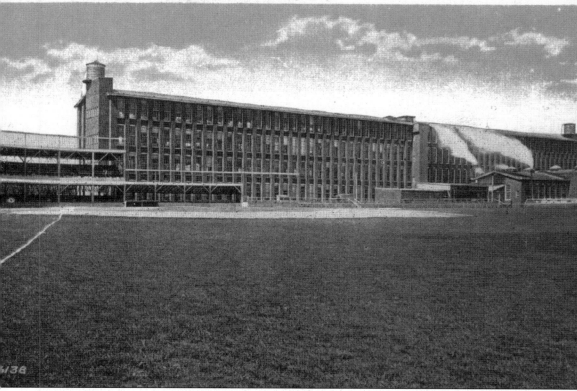

You very well might have heard the call "Play ball!" along Main Avenue in the 1920s, when Doherty Oval, alongside the mill, sported the Doherty Silk Sox. Henry Doherty's mill linked Clifton with the rich history of neighboring Paterson, then known as "Silk City." Doherty hailed from Macclesfield, England, as did the "father" of the Paterson silk industry, John Ryle. In fact, by 1897, 15,000 people from the silk-manufacturing town of Macclesfield had emigrated to Paterson. England had dropped tariff protections for its domestic silk industry, leading the French to export cheaper silk to the United Kingdom. Macclesfield's silk industry suffered as a result, leading to the exodus. (Courtesy of the Van Dillon and Mark S. Auerbach Collections.)

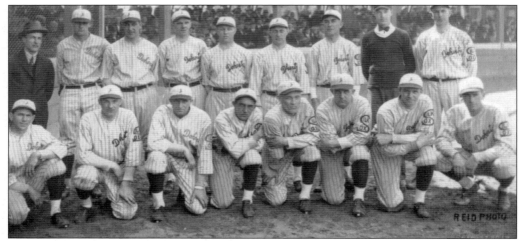

The Doherty Silk Sox, the semipro team backed by Harry L. Doherty, played major league teams at its home field in Clifton. That was because blue laws prohibited games in many big cities on Sundays. Not in Clifton. Babe Ruth played with the Yankees at the Doherty Oval. The Silk Sox even beat the Yankees. Some Yankee greats took stake in Clifton's future, too. In the late 1950s, Yogi Berra and Phil Rizzuto opened a bowling alley bearing their names at Styertowne shopping center. (Courtesy of the Van Dillon Collection.)

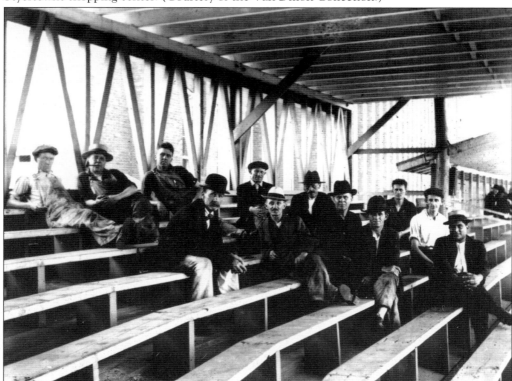

Up close in the stands of the Doherty Oval, these fans pose for the photographer c. 1920. Doherty's fortunes eventually faded, and his silk mill was sold in a sheriff's auction in 1940. (Courtesy of the Clifton Public Library.)

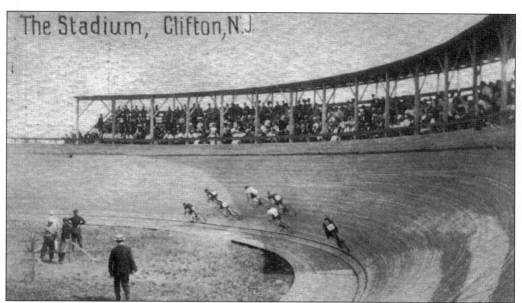

The Stadium, Clifton, N.J.

"Consternation in Clifton / Has the Action of the Grand Jury Put an End to the Racing?" read a headline in 1891, after bookmakers for the Clifton Racetrack were indicted. The track, near Main and Piaget Avenues and Christopher Columbus Middle School (the old high school), was a destination point, a place to watch the horses. On this day in January, though, "loaded trains reach the gate as usual and find the gates closed." (The Erie Railroad ran special trains from New York to the track.) Guilty verdicts were handed down, and a constitutional amendment forbade all forms of wagering. In 1909, the sender of the above postcard wrote to an acquaintance in Lancashire, England, that "Clifton is one mile from Passaic. The picture shows low-key race Sunday afternoons." By then, the track had been converted into a velodrome for bicycle races. The view below shows the track in a quieter time, c. 1895. By the mid-1920s, the track was gone and a new Clifton High School was to rise in its stead. (Courtesy of Van Dillon and Mark S. Auerbach Collections.)

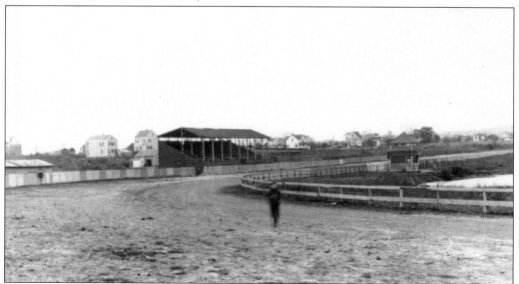

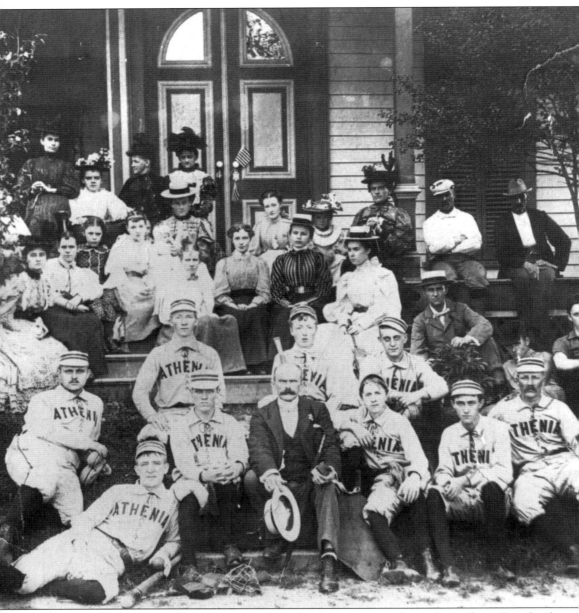

Sports-minded individuals could join up with the Athenia team, shown here after a Fourth of July game in the early part of the 20th century. There was a small oval in the Colfax Avenue vicinity at the time. With the Doherty Silk Sox not far away, baseball was king in Clifton. (Courtesy of the Libbey and Van Dillon Collections.)

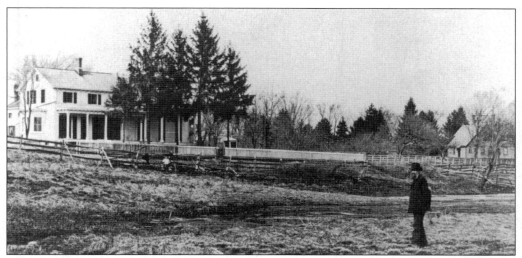

Standing atop a Victoria Regia water lily, below, is Emma Porter Nash, at Scotto Nash Aquatic Gardens, c. 1894. A few years later, c. 1900, the Scotto Nash home, above, could be seen at Lexington Avenue and the Passaic River. The area is now home to Nash Park. A nature lover, Scotto Nash grew roses deemed to be some of the best in the country. Because of his efforts, Acquackanonk Township became known as the "Home of the American Beauty Rose," a species he imported from England in 1882. His aquatic gardens were the result of hard work. A swamp was turned into a sunken tropical garden by the use of steam pipes connected to a boiler, thus funneling warm water to his plants. (Courtesy of Clifton Public Library and Van Dillon Collection.)

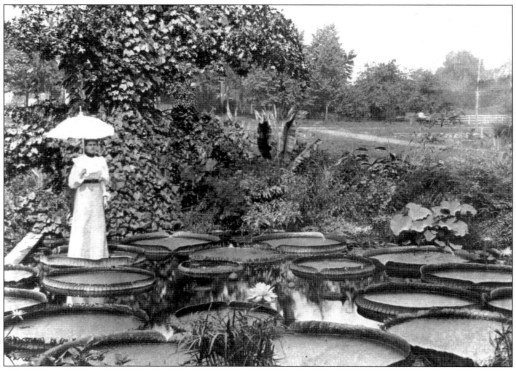

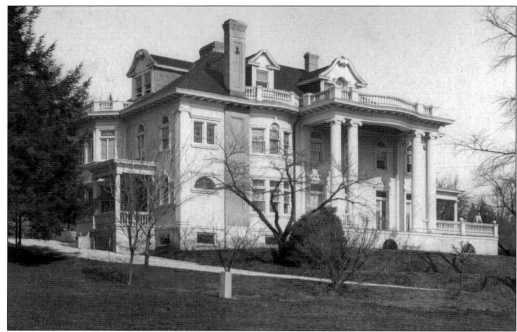

This 1908 mansion, located at the northern end of Valley Road in the Albion section, is now a charter school and before that it was the Dollymont Nursing Home. However, early in the 20th century, it was home to William Gourley, Passaic County prosecutor. The Irish-born Gourley, who later served as Clifton counsel, gave a rousing speech for conscription on the dawn of American involvement in World War I. This photograph was taken by J. Reid, a noted Paterson photographer of the period. (Courtesy of the Mark S. Auerbach Collection.)

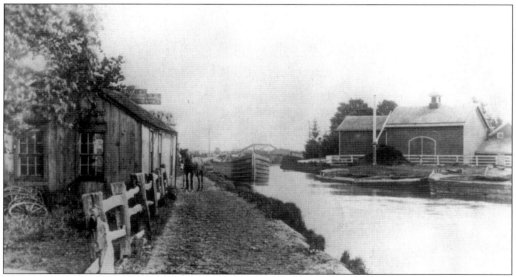

The Morris Canal was the lifeblood of the crossroads of Van Houten Avenue and Broad Street. Wooden bridges carried the roads over the canal, seen here c. 1900. A blacksmith shop stood on the left, as did Kesse's Richfield Hotel. (Courtesy of the Van Dillon Collection and the Clifton Historical Commission.)

The Elk's Club sat at Clifton and Colfax Avenues, as it does today, but the original structure was eventually replaced by a modern brick building. The only thing still recognizable today is the stone wall alongside the sidewalk. (Courtesy of the Mark S. Auerbach Collection.)

Shown c. 1910, this 12-room house, located at 806 Clifton Avenue, was razed in 1957 to make way for the Clifton Boy's Club. As with that of the Elk's Club, the house's French Second Empire mansard roof was typical of the area. (Courtesy of the Van Dillon Collection.)

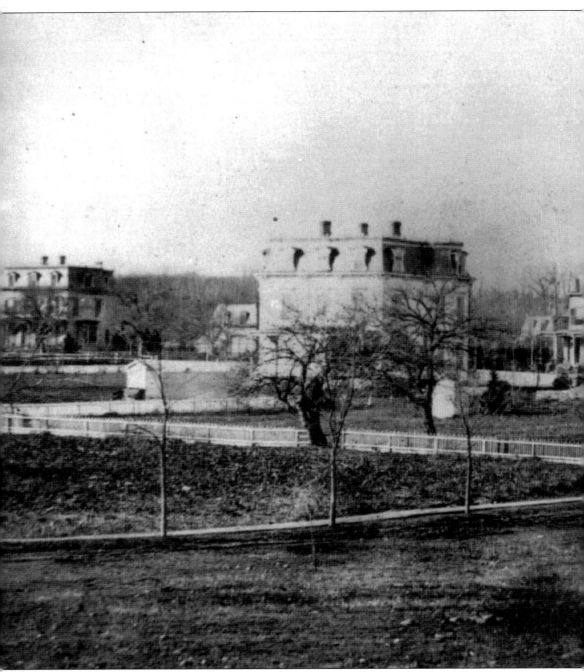

The distinctive Second Empire mansard roofs of Athenia mark the skyline of Acquackanonk in the 1880s. This view is from the Lackawanna Railroad and shows Clifton and Colfax Avenues to the left of center. In 1873–1874, brothers George and John Hughes built 15 large houses on property acquired in a real estate venture. Among the structures were the Elks Club and the church house of the Athenia Reformed Church. The brothers' business failed in the panic of 1874, and the property was mortgaged to principals of the Singer Sewing Machine Company.

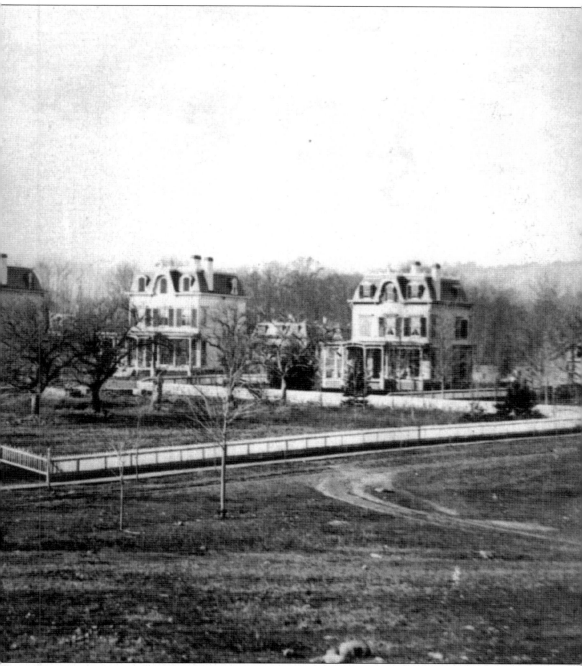

The company's treasurer, Hugh Cheyne, purchased one of the houses in 1881 and moved his family there from New York. Cheyne was among those who suggested the name Athenia (after the Greek goddess Athena) for the section of town then known as Centreville. Since there were so many Centrevilles in the state, the newly formed post office was forbidden from using that name. (Courtesy of Van Dillon Collection.)

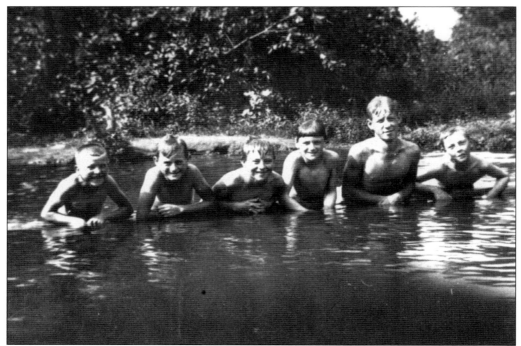

In 1901, the "Old Swimming Hole" of Weasel Brook, near today's Clifton High School, brought out, from left to right, George Crawford, Alex Hiehten, Alex Crawford, ? Morrison, Prescott Godwin, and Ray Kirchner. "There were only two prerequisites," wrote David Van Dillon in *A Clifton Sampler,* "no bathing suit, and a waist deep stance in the water when a passenger train went by." (Courtesy of the Van Dillon Collection.)

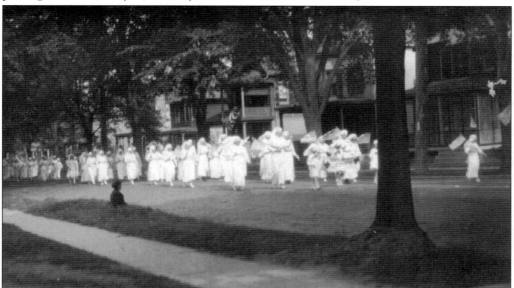

In 1914, the war is on in Europe and the women of the Red Cross march up Clifton Avenue having just passed Third Street. Two girls lead the way, carrying banners with the only legible words being "Home" and "Clifton." (Courtesy of Clifton Public Library.)

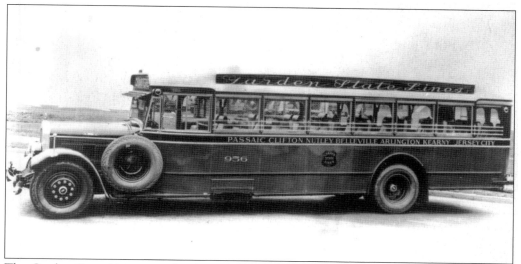

The Garden State Lines served at least seven communities, Clifton included, as can be seen from the markings on one of its buses. (Courtesy of the Van Dillon Collection.)

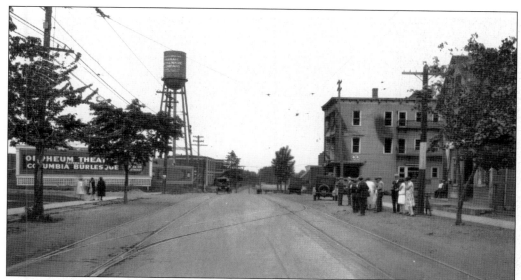

The approach to Passaic from the Delawanna side of Main Avenue made for some interesting reading back in the 1920s. The smaller print on the theater billboard on the left reads: "It's worth the ride. Columbia Burlesque, which means it's clean." The water tower reads Passaic Metal Ware Company, later the Continental Can Company. It was here that the old Coca-Cola "tip trays" were manufactured. (Courtesy of the Van Dillon Collection.)

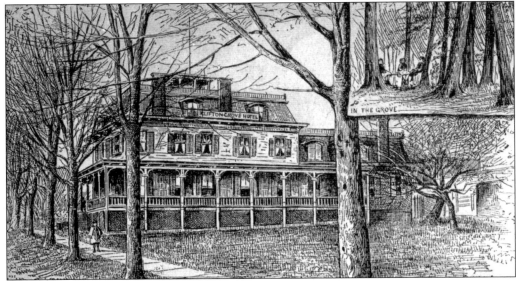

The Clifton Grove Hotel, shown above in a *c.* 1890 real-estate advertising booklet and below years later after a post-fire remodeling, was built at Main and Madison in 1869. It provided accommodations to visitors to the Clifton Racetrack. Across the street, between Madison and De Mott Avenues, stood a picnic grove, where the hotel had a pavilion for bands and orchestras. In an 1872 advertisement, the hotel is touted as "one of the most delightful places out of New York." In October 1942, though, it met its final demise. "IT'S GONE," read a caption under a picture of the hotel. "The old Clifton Hotel, a landmark and once the popular rendezvous of politicians and sportsmen, torn down recently, was the scene of two fires Saturday night. The rubbish burned fiercely for a while, giving hundreds of theatergoers a thrill as firemen stumbled through the wreckage." (Courtesy of the Van Dillon Collection.)

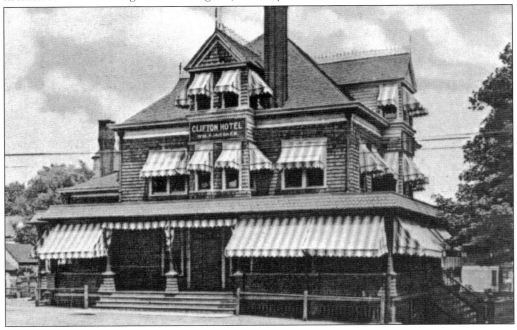

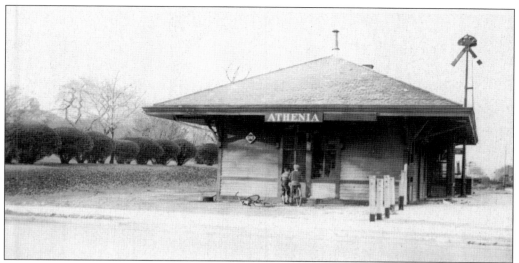

Bicycle-riding boys, above, make a stopover at the Athenia train station *c.* 1930. Behind those windows a few years earlier, in 1924, railroad agent Llewellyn L. Lloyd, below, is seen in his office. (Courtesy of the Van Dillon Collection.)

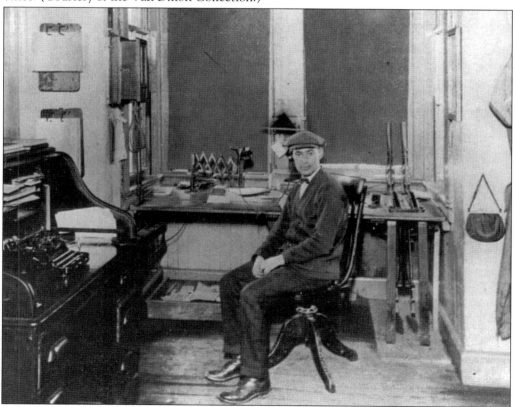

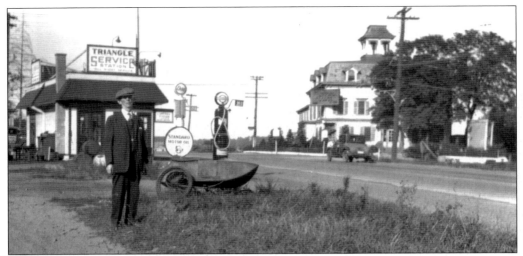

The Triangle Service Station stood at Broad and Van Houten *c.* 1930, close to Kesse's Richfield Hotel, seen on the right. Later known as the Clifford Lodge, the hotel was lost to fire on April 10, 1932, and was never rebuilt. Eight people were injured in the fire. (Courtesy of the Van Dillon Collection.)

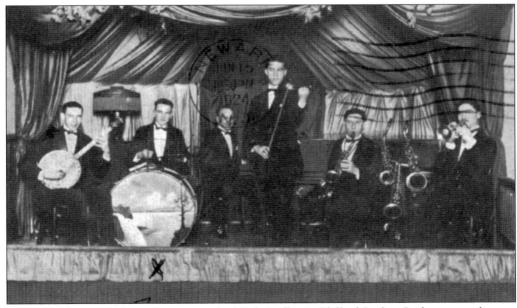

The 1924 postmark dates this postcard of Bob Fridkin's Clifford Lodge Orchestra, a place to "dine and dance every evening." The Clifford Lodge was one of the various incarnations of Kesse's Richfield Hotel. (Courtesy of the Mark S. Auerbach Collection.)

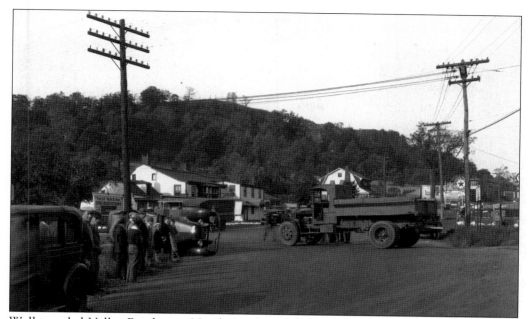

Well-traveled Valley Road, near Notch Road, was the scene of an auto accident in October 1932. The view includes a glimpse of the Great Notch Inn, on the left, with Washington's Lookout behind it. (Courtesy of the Van Dillon Collection.)

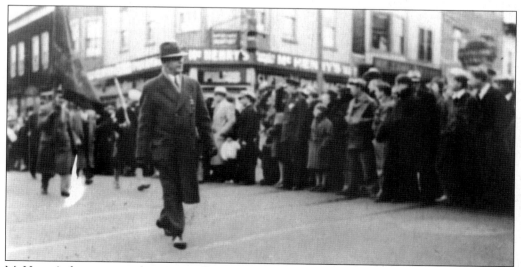

McHenry's drugstore, at the corner of Main and Clifton Avenues, can be seen over the shoulder of this marcher in the Armistice Day Parade in 1934. The year marked the election of Mayor Wilson S. Brower and the switch from a council to a council-manager form of government. (Courtesy of John Forstmann Library and the Van Dillon Collection.)

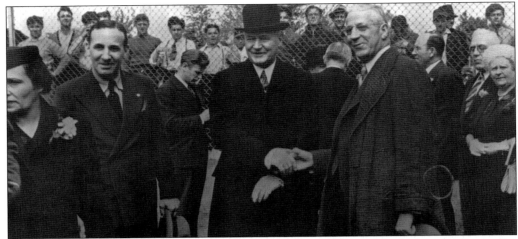

An international visitor, President Samoza of Nicaragua, visits Clifton's Magor Car Corporation in May 1939. He is greeted by Gov. Harry Moore of New Jersey and J.W. Lewis, vice president of the railcar builder. The company, founded in 1899 and incorporated in 1917, exported many railcars. Its railcars were used for military purposes in Europe, and it was the principal builder of cars under the Marshall Plan. In the 1960s, the demand for railcars began to decrease, and the company closed in 1973. (Courtesy of the Van Dillon Collection.)

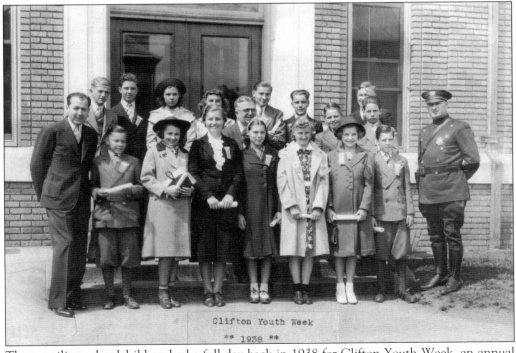

These smiling schoolchildren had a full day back in 1938 for Clifton Youth Week, an annual event that remains a fixture in Clifton. Here, the group is standing outside the old City Hall complex on Main Avenue. (Courtesy of the Clifton Public Library.)

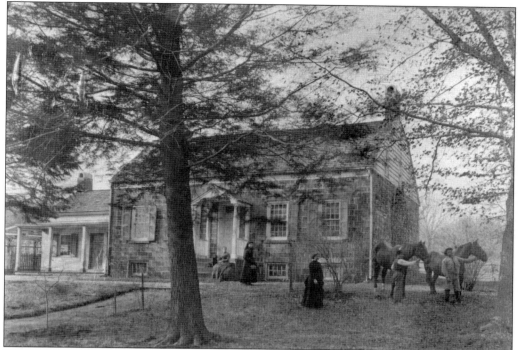

The Hamilton House stood on the west side of today's Valley Road, near the intersection of Routes 46 and 3, where townhouses are today. In perhaps the oldest known photograph of the building (above) are three women believed to be Bridget, Margaret, and Susan Hamilton. In 1973, the house (below) was lifted and moved southeast across Valley Road, where today it serves as a museum, with events held during the year, in Clifton's Montclair Heights section. (Courtesy of the Hamilton House Museum.)

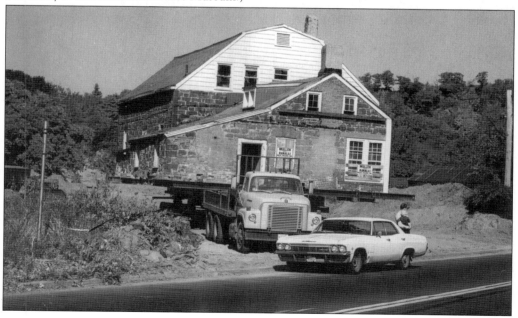

The Hoffmeier Farmhouse, on Broad Street near today's Greglawn Drive, was an 18th-century home sold to Henry Schoonmaker at a public auction in 1827. The house was acquired by the Hoffmeier family in 1906. In 1965, it was demolished to make way for three single-family homes. (Courtesy of the Van Dillon Collection.)

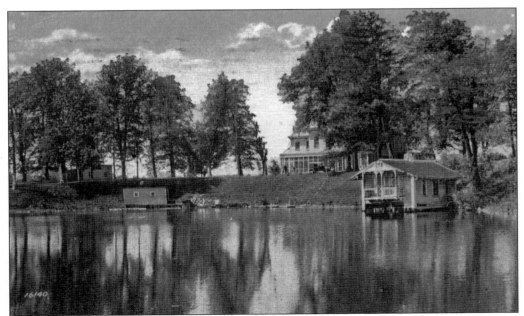

An idyllic view could be had at Normandie Park, in Clifton's northeast corner, overlooking Dundee Lake. It was located where Roosevelt Avenue meets Route 46. (Courtesy of the Mark S. Auerbach Collection.)

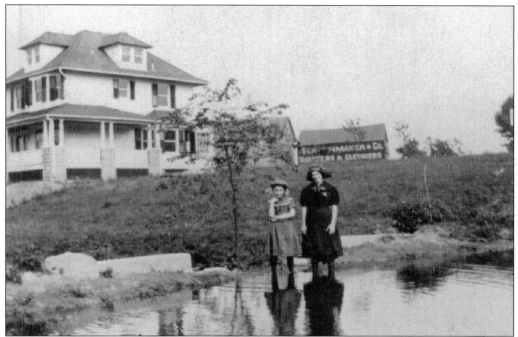

This scene was at Butz's Pond, near Clifton and Van Houten Avenues, c. 1915, . The house, now the location of Schneider's Florist, was purchased from attorney Arthur Butz in 1949. The pond, where a corner gas station is today, was filled in and the stream was diverted by culverts. (Courtesy of the Van Dillon Collection.)

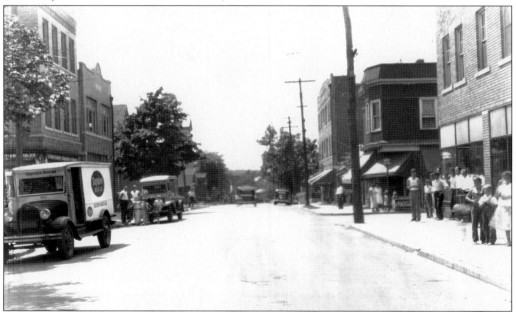

On the far eastern end of the Athenia section, a bread truck stops for a delivery in the 1920s. To the photographer's back is the Raybestos-Manhattan rubber factory. (Courtesy of the Clifton Library.)

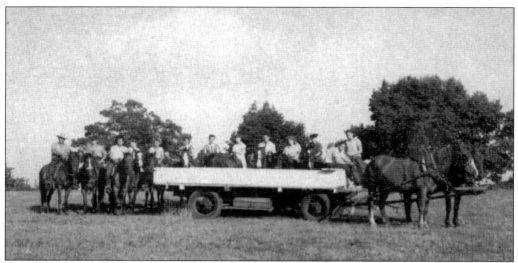

"Riding horses for hire – hay rides and riding parties organized," reads the message on this undated postcard of the Allwood Riding Stables, at 214 Allwood Road. The proprietor is listed as John Chello. (Courtesy of the Mark S. Auerbach Collection.)

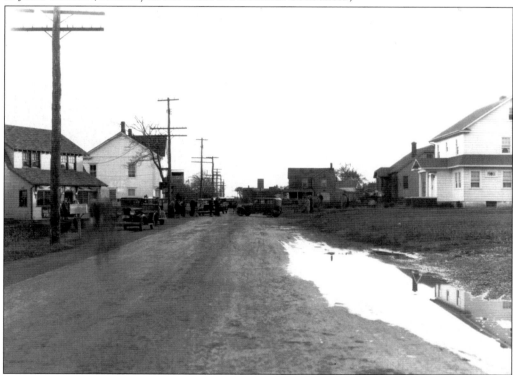

Broad Street was a dirt road in this 1932 view from the corner of Colfax Avenue, looking south toward the Richfield Firehouse and Crowley's Ice Cream. Some of the homes are clearly identifiable today. It was on December 24, 1932, that the Richfield Firehouse opened. The year was also marked by the opening of Wessington Stadium on Main Avenue, opposite the Doherty Oval. (Courtesy of the Clifton Public Library.)

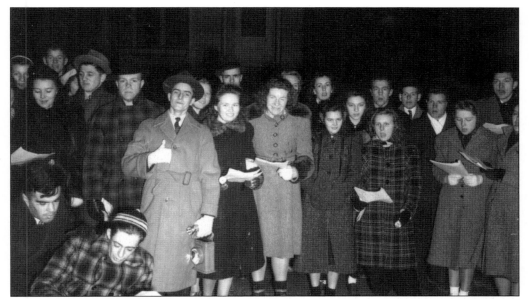

Churchgoers sing carols as part of the Athenia Reformed Church's Christian Endeavor *c.* 1939. In this scene on Colfax Avenue, young David Van Dillon, later Clifton historian, appears in the left foreground. (Courtesy of the Libbey and Van Dillon Collections.)

Rentschler's Swimming Pool, later known as Bellin's, was the place to be in 1931, the year after its opening. The Main Avenue club, near the old Herald News building along the Passaic border, is a Clifton mainstay. Clifton's population was about to get a boost in 1931, when Charles H. Reis began construction of 400 homes on the site of the former Brighton Mills in the Allwood section. (Courtesy of the Mark S. Auerbach and Van Dillon Collections.)

Just ahead of the postwar suburban housing boom, this neighborhood of homes rose along Cloverdale Road, west of Elm Street, *c.* 1942. Farther west near Valley and Van Houten, 350 one- to four-family homes were being built one year earlier by the government for defense workers from the Curtiss-Wright Aeronautical plant in Paterson. The development was called Acquackanonk Gardens. Also in 1941, work began on S-3, now Route 3, and S-6, now Route 46. An April newspaper report stated: "Work on two major highways was shifted into high gear in Clifton this week. Preliminary grading work was inaugurated on S-3 through Allwood and preparations for paving are being made on R-6 through Piaget Avenue." The first route linked Great Notch with the Lincoln Tunnel and the second route linked the Delaware Water Gap with the George Washington Bridge. (Courtesy of the Van Dillon Collection.)

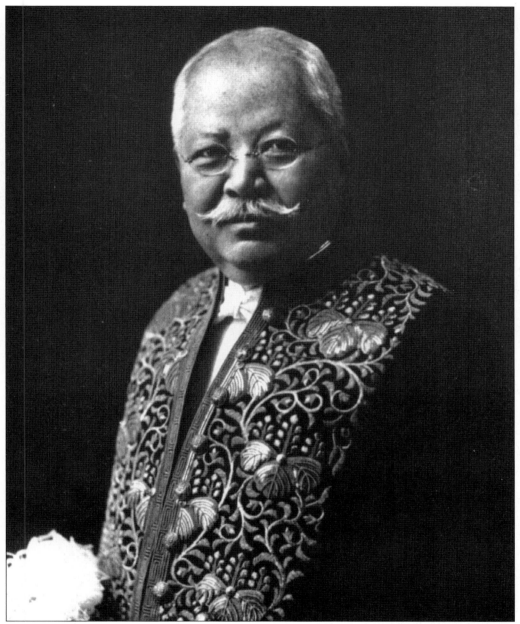

Dr. Takimine Jokichi, the chemist who isolated adrenaline, served in the employ of the Japanese government from 1881 to 1884 and within a few years organized a fertilizer company. In 1890, he settled in the United States, doing research in applied chemistry and isolating adrenaline in 1901. He opened a starch digestant plant on Arlington Avenue c. 1915, and died seven years afterward, in 1922. The day after Pearl Harbor was bombed, in December 1941, the plant, which was then operated by his son Eben Jokichi, was seized by the U.S. government amid confusion over whether it was Japanese owned. Within days, the plant was cleared and reopened. A short while later, Eben Jokichi became ill and the company was sold to Miles Laboratories.

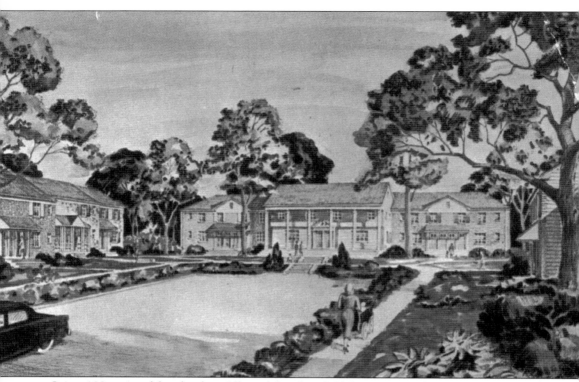

Some 108 acres of farmland at Allwood Road and Clifton Avenue became Richfield Village Apartments after the planning board approved a proposal on June 12, 1948 for the construction of garden apartments. In the mid-1950s, the above postcard carried this description: "These spacious apartments built by Joseph J. Brunetti, New Jersey's most extensive builder. This development consists of approximately 2,000 units of 2, 3, and 4-room apartments and a beautiful shopping center." The note penned on the postcard, however, spoke of ownership: "Bought a home in Clifton. New address, 185 Union Ave." (Courtesy of the Mark S. Auerbach Collection.)

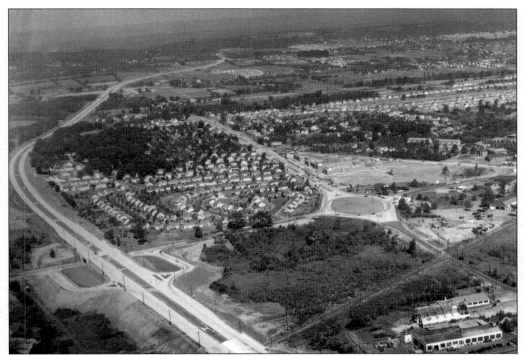

Growth was in full swing, but this aerial view of the Allwood Circle predates the building of the Styertowne Shopping Center, on Route 3 westbound. (Courtesy of Clifton Merchant Magazine.)

Clifton's eastern expanse of Rosemawr, between Main Avenue and Passaic Avenue, can be seen from the air in this picture. (Courtesy of Ridgelawn Cemetery, Van Dillon Collection.)

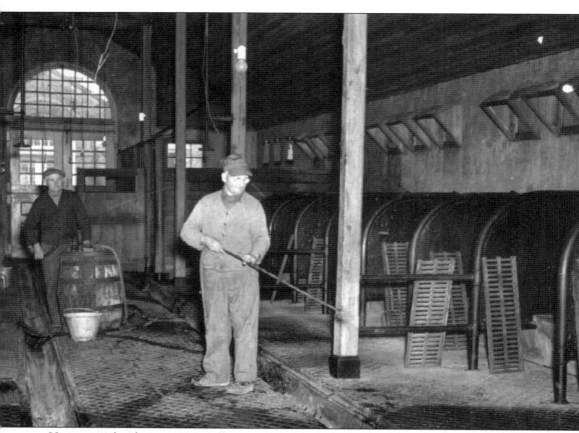

Horses, cattle, sheep, swine—all were imported. Those animals and others could be found at the U.S. Quarantine Station. What was described as "a barren hillside farm of 50 acres at Athenia" became the home of the quarantine station at the start of the 20th century, some 20 years after an "appalling" outbreak of contagious pleuropneumonia swept through the nation's cattle herds and cost breeders millions of dollars. Here, at the corner of Van Houten and Clifton Avenues, in what was to become Clifton, the herds were kept for 60 to 90 days after arrival by train at the nearby Erie station. If taken ill, their carcasses would be burned. No one could enter without a special permit, of which few were given. A piece of the station was given over to a new high school in the early 1960s. In 1980, after much negotiating, the federal government passed the property to Clifton for a new municipal complex, and the old barns were put to use. A new Arts Center was added. "The plan upon which the Athenia station is laid out resembles a checker board," said a newspaper article of the time. "Each stable stands in the middle of a large lot, which is in turn separated from the other lots by broad avenues."

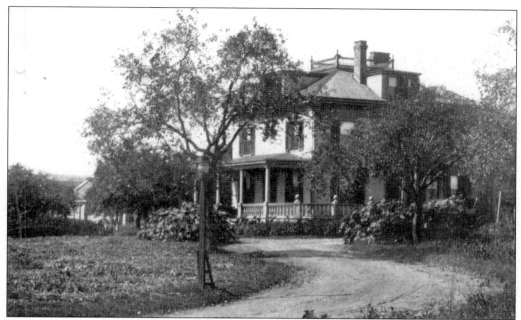

The superintendent's house (above) and the barns (below) of the U.S. Quarantine Station still stand today, on the grounds of the Clifton Municipal Complex. In a 1905 newspaper article, the home is described this way: "At the front of the reservation stands a handsome and commodious house for the inspector and his family, with a stable and other domestic outhouses in the rear." (Courtesy of the Van Dillon Collection.)

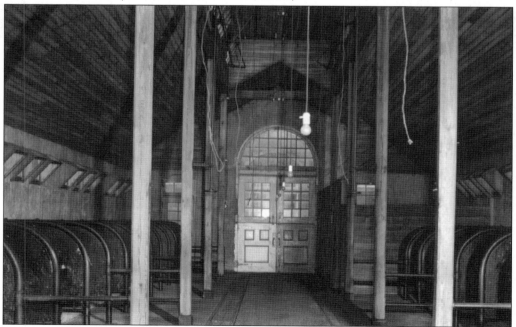

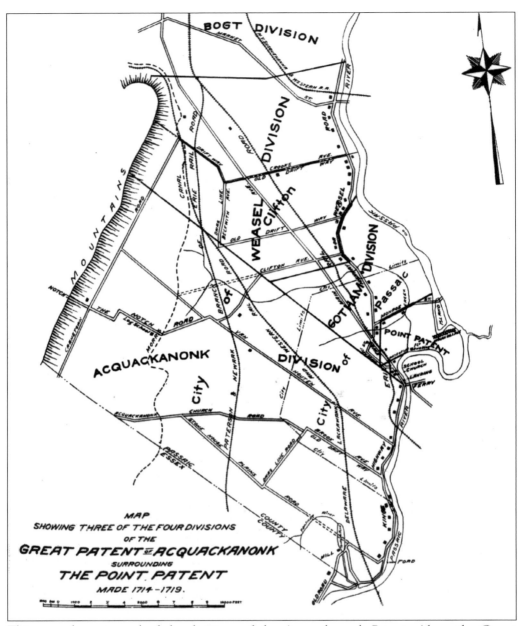

This map shows several of the divisions of the Acquackanonk Patent. Along the Garret Mountain range is Cranetown Road, today's Valley Road. To the center right is the city of Passaic. Clifton is said to be shaped like a horseshoe because of the way Passaic pokes into its border.

Two

DOWNTOWN
AND ENVIRONS

*The inquiry often comes from persons living in crowded quarters
of New York, and paying excessive rents: "Where can I find a quiet,
healthful place, convenient to my business, where I can economize without
suffering in mind, and escape the everlasting squeeze of an over crowded city?"
It [Clifton] is a quiet, orderly, happy community, where children can enjoy
freedom with safety and parents can spend their days in peace.*

—L.F. Spencer, agent Clifton Land and
Building Association, early 1900s

Tennis anyone? The southwest corner of Main and Clifton Avenues is seen in an updated photograph, with the Clarkson and Thurburn houses in the background. (Courtesy of Clifton Public Library.)

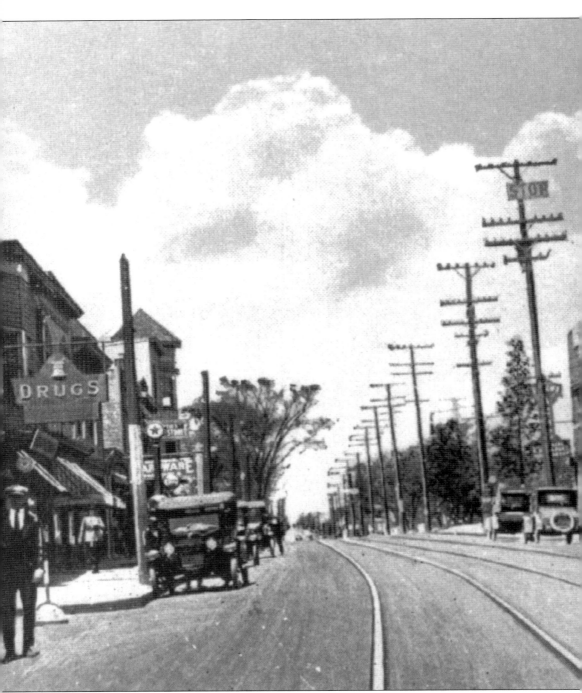

Clifton's crossroads—Main and Clifton Avenues—still had trolley tracks when this image was captured for a postcard in the 1920s. Note the stop sign atop the telephone pole (center) and the smaller go sign next to the traffic officer (right). Some of the major transformations of the 1920s were the Clifton City Council votes to establish a free public library, which opens in a storefront on Main Avenue in 1921; the city gets sanitary sewers; the Clifton Kiwanis meets for

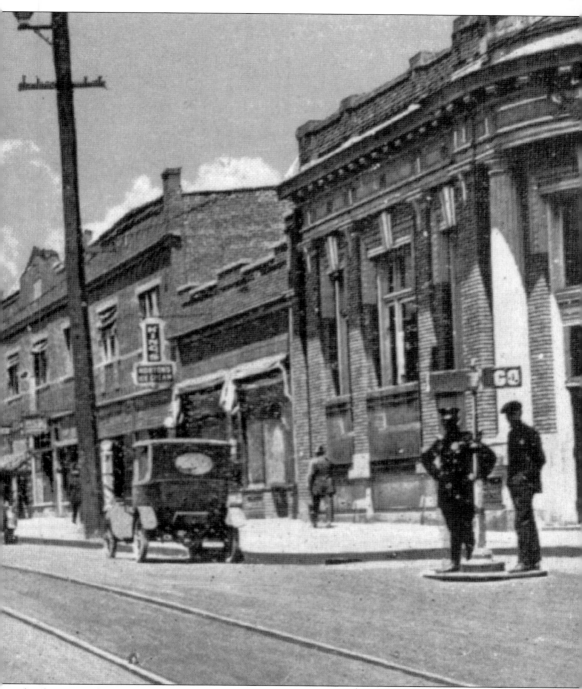

the first time; bus service to New York City begins (in 1925) from Main Avenue via Intercity and from Lakeview and Lexington via Manhattan; and Rutt's Hut opens in Delawanna. By the end of the decade, Clifton had 46,875 residents. (Courtesy of the Van Dillon and Mark S. Auerbach Collections.)

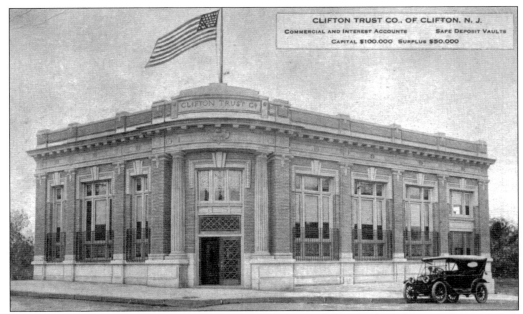

A sizable Old Glory flies atop the Clifton Trust Company (above) which became the city's first bank c. 1915. A postcard c. 1920 showing the bank's interior (below) notes capital of $100,000, and a surplus of $50,000. One of the early vice presidents was George S. Schmidt, Clifton's first elected mayor. When the bank was dedicated, I.A. Hall, the bank's organizer, pulled a cord releasing the large flag and unfurling hundreds of smaller flags in the process. Cheers rose from high school students who formed a line across Main Avenue from the bank and then scrambled for the red-white-and-blue prizes. The corner bank remains largely unchanged today. (Courtesy of the Mark S. Auerbach Collection.)

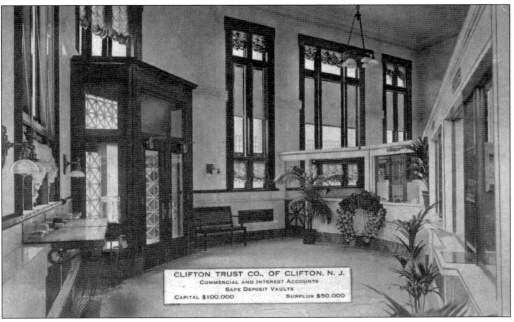

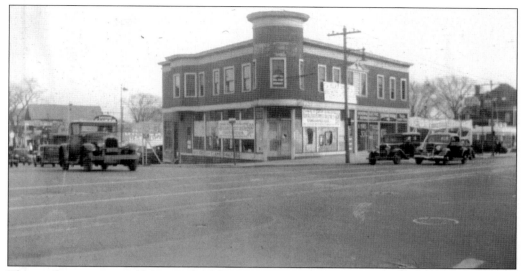

The southeast corner of Main and Clifton avenues is seen *c.* the 1920s. (Courtesy of Clifton Merchant Magazine.)

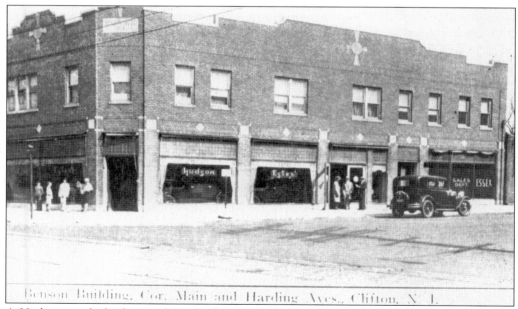

Benson Building, Cor. Main and Harding Aves., Clifton, N. J.

A Hudson car dealership, with its display windows, could be found at the Benson Building, at Main and Harding Avenues, a block from Clifton Avenue. The Hudson Motor Car Company merged with Nash-Kelvinator Corporation in 1954, forming American Motors Corporation. It was later folded into Chrysler. (Courtesy of the Van Dillon Collection.)

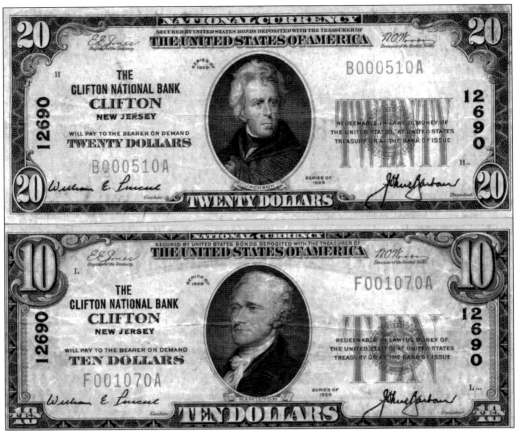

The Clifton National Bank stands on Main Avenue in the postcard below, but the 1928 notes above bear the bank's name. Today, the building is a PNC bank. (Courtesy of the Mark S. Auerbach Collection.)

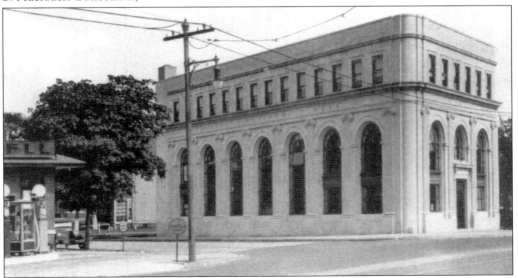

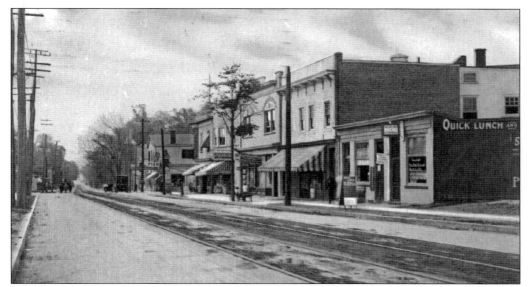

For anyone who might venture off the trolley running between Paterson and Passaic, a "quick lunch" (as the sign says) could be had along this section of Main Avenue. The view looks south from the corner of Passaic (now Harding) Avenue. (Courtesy of the Mark S. Auerbach Collection.)

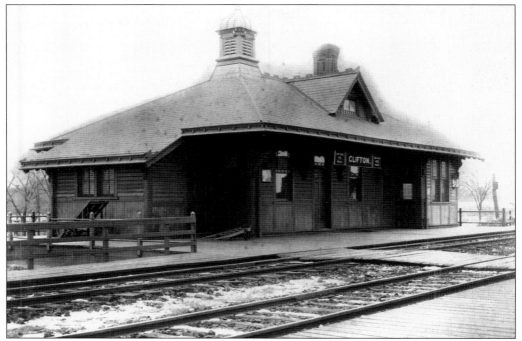

The Clifton station of the Erie Railroad is shown in this late-1800s photograph at Getty and Madison Avenues. It was built in 1860 and burned in 1950. In the 1870s, the nearby Clifton Grove Hotel touted its proximity to the railroad, also noting its convenient location just three miles from Paterson, 12 miles from New York, and "only 50 minutes" from the Chamber Street Ferry. (Courtesy of the Clifton Library.)

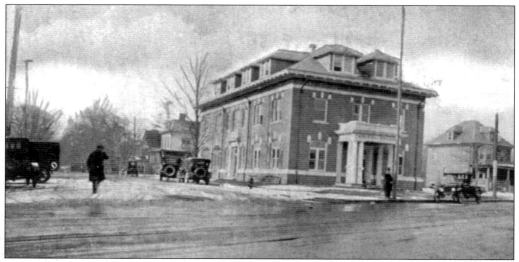

Seen below is Clifton City Hall, on the corner of Main and Harding, before the addition of dormers. Seen above, in a later postcard, is the building after dormers have been added. The building was erected as Acquackanonk Township's town hall in 1914, becoming Clifton City Hall in 1917. Later, an adjoining police headquarters was erected.

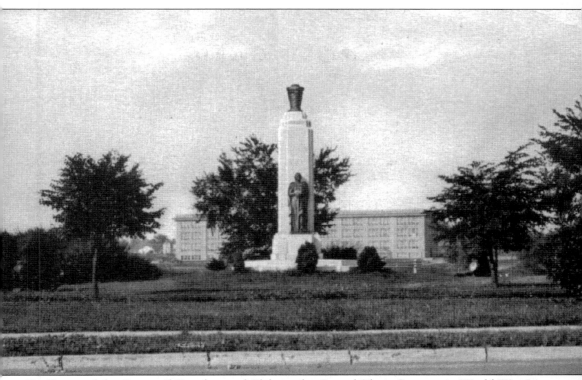

"In Honor of the Sons and Daughters of Clifton who Served Their Country in World War I, World War II, Korea and Vietnam," reads the newer inscription in what was originally known as the World War Memorial, shown standing in the then newly opened Memorial Park in this pre–World War II postcard. Note the 1926 version of Clifton High School, now Christopher Columbus Middle School, in the background. It was on November 11, 1929, Armistice Day, that the monument was dedicated. It was designed by William E. Brown of Clifton and sculpted by internationally known artist Gaetano Cecere. The day was quite an event, as noted in a 1987 article by Clifton historian William J. Wurst: "Some 1,000 marchers kicked off the day's festivities with a huge parade through Clifton's flag-decorated streets." By the time the entourage arrived at the park, the crowd had swelled to 5,000. The monument bears a bronze figure of a sword-carrying woman with the "laurels of victory" and a shield bearing gold stars in memory of the dead. The bronze urn atop the stone shaft contained a perpetual light. (Courtesy of the Mark S. Auerbach Collection.)

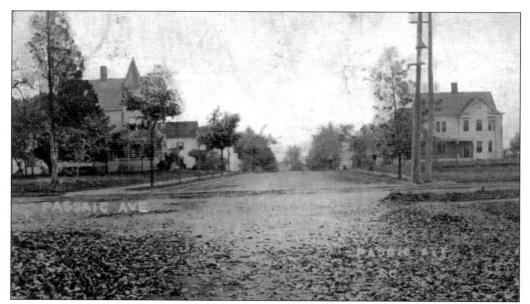

Passaic Avenue was not yet renamed Harding Avenue, after President Warren G. Harding, when this postcard was circulated. The sender wrote: "Am here in Clifton for a visit. It has been such fine weather that we are enjoying ourselves." (Courtesy of the Mark S. Auerbach Collection.)

The Clifton Masonic Club, at 97 Passaic (now Harding) Avenue, was dedicated on April 14, 1925, in ceremonies in the newly acquired building. A dinner was catered by David Wilson of the Arrow Restaurant, on Main Avenue. A. Harry Moore, the Democratic nominee for New Jersey governor, was the principal speaker. In 1938, the club was sold to Quentin Roosevelt Post No. 8, American Legion. The Clifton Craftsmen Club met here from 1948 to 1953.

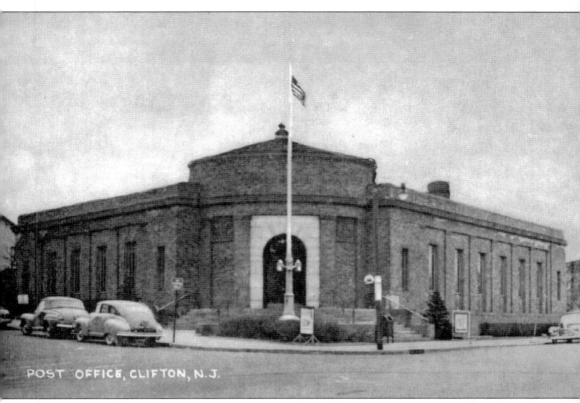

POST OFFICE, CLIFTON, N. J.

Its price tag was $150,000. Its location was at Main and Washington Avenues. The May 17, 1936 edition of the *Passaic Herald News* noted that 2,000 attended the dedication of Clifton's new letter center, as the post office band played "The Star-Spangled Banner." The Reverend George B. Grambs of St. Peter's Episcopal Church gave the invocation, and the master of ceremonies was Freeholder Ernest T. Scheidemann. "A street parade, led by Clifton policemen and firemen and five bands," read an account of the day, "proceeded through the principal streets of the city before the services started. Hundreds of people lined the curbs to watch the procession, which led from the old building on Union Avenue to the new Post Office." (Courtesy of the Mark S. Auerbach Collection.)

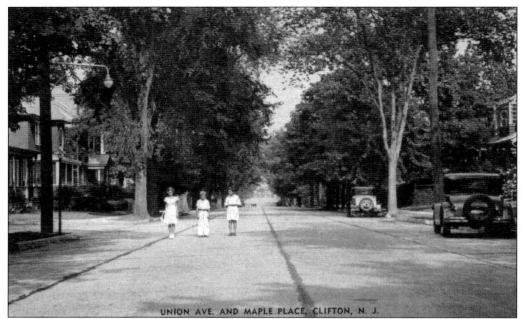

In this *c.* 1930s postcard, children pose for the camera along Union Avenue, with the photographer looking east from the intersection with Maple Place. Note the scarcity of automobiles. It was on Maple Place where Walter F. Nutt, who served as Clifton High School principal and then as mayor from 1946 to 1950, was stricken in 1953 while shoveling snow outside his home. He was 71. (Courtesy of the Mark S. Auerbach Collection.)

Union Avenue is shown west of Maple Place. (Courtesy of the Mark S. Auerbach Collection.)

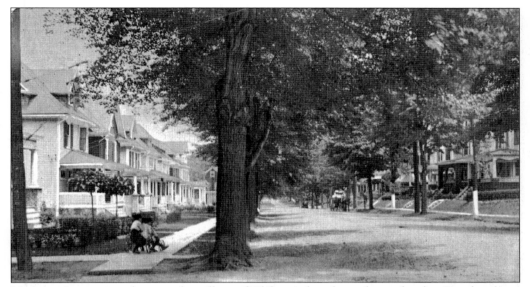

Madison Avenue in what was the village of Clifton is largely unchanged today. For the above view, with the children on the sidewalk, the photographer was looking east from Second Street *c.* 1910. (Courtesy of the Mark S. Auerbach Collection.)

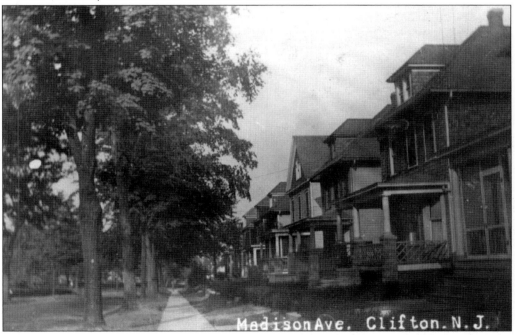

Madison Ave. Clifton. N. J.

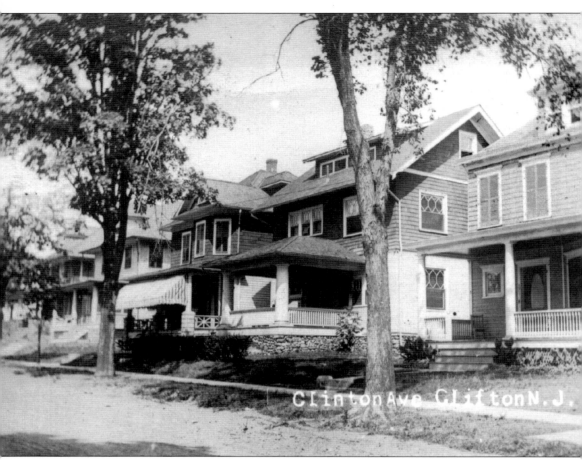

Clinton Avenue was a typical downtown street, between Main and First, *c.* 1905. Save for the dirt road, it is largely unchanged. A few years, the Erie Railroad link to the Hudson tubes had landowners trying to fire up interest in real estate. "You work day after day and year after year," begins an ad by Augustus Nathan at Madison and Third Street, "What have you got to show for it? If the answer is unsatisfactory, read this proposition" He goes on to offer 35-by-115-foot building lots at $450 each, with $7.50 down and $1.75 a week. "Just 25 cents a day," it adds. There is, however, no mention of the term of the loan. (Courtesy of the Mark S. Auerbach Collection.)

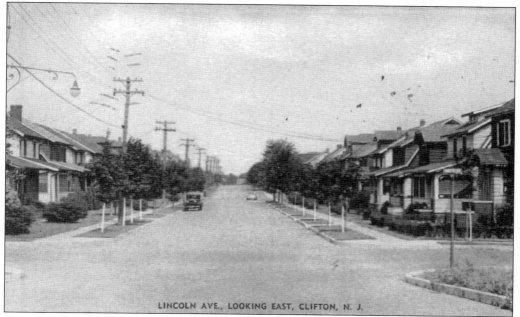

LINCOLN AVE., LOOKING EAST, CLIFTON, N. J.

This view of Lincoln Avenue, looking east from Sixth Street, was taken *c.* 1940. The following year, new-home building began at a fever pitch in the nearby Allwood section, when Walter J Harring bought land from Charles Reis and erected 500 homes before the onset of World War II. (Courtesy of the Mark S. Auerbach Collection.)

Spring Street, near the corner of Paulison and Clifton Avenues and near Dutch Hill, was a new neighborhood when this postcard was in circulation. (Courtesy of the Mark S. Auerbach Collection.)

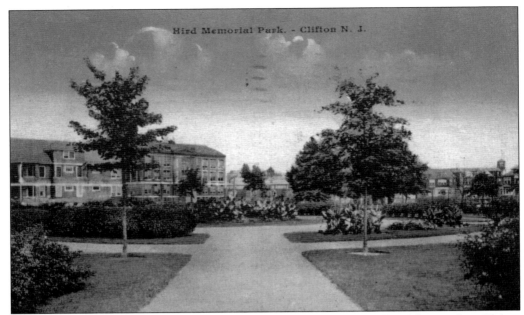

Samuel Hird, a textile magnate who lived from 1850 to 1922, donated land for a park at Clifton and Lexington Avenues. The newly named Hird Memorial Park is shown in this postcard dated 1929. Hird operated a worsted mill in Garfield at the beginning of the 20th century, Later, Hird's family opened a plant at Clifton and Paulison Avenues in Clifton, where sheep grazed into the 1960s. (Courtesy of the Mark S. Auerbach Collection.)

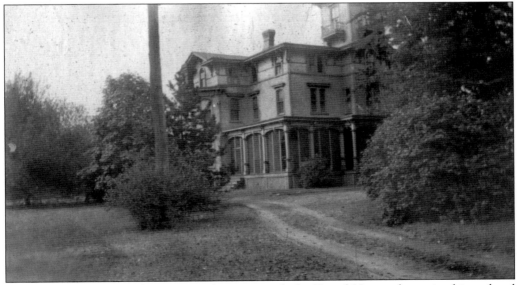

At East Ninth Street and Lexington Avenue stands the Dewal House, shown in this updated photograph. (Courtesy of Clifton Merchant Magazine.)

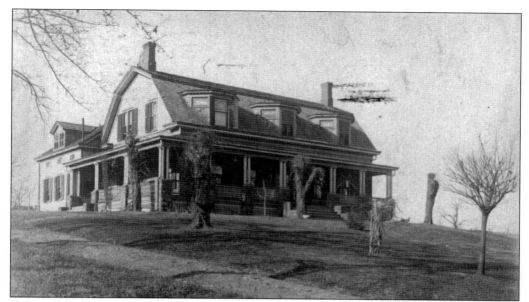

Henry Garritse, a patriot, lived in this house, near the northwest corner of Clifton and Lexington Avenues. It was considered one of the finest examples of Dutch Colonial architecture. The house, built in the late 1660s, was razed in 1968. A later street scene of nearby Lakeview Avenue (below) was taken looking north from Garritse Place. (Courtesy of the Mark S. Auerbach and Van Dillon Collections.)

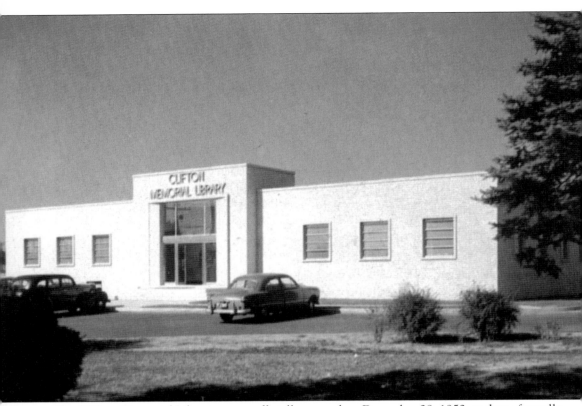

The Clifton Memorial Library was unofficially opened on December 29, 1952, and was formally dedicated a month later. Henry Fette of Fette Ford was the chairman of the building campaign. Nearly 40 years later, it was demolished and replaced by a parking lot for a new larger library, dedicated on November 10, 1991. There were many moving days. A year after the Clifton City Council voted to establish a free public library in May 1920, it operated out of a storefront on Clifton Avenue, moving again in 1929 to 68 Union Avenue. By 1943, the library again relocated to 99 First Street, which today is the county probation department. (Courtesy of the Mark S. Auerbach Collection.)

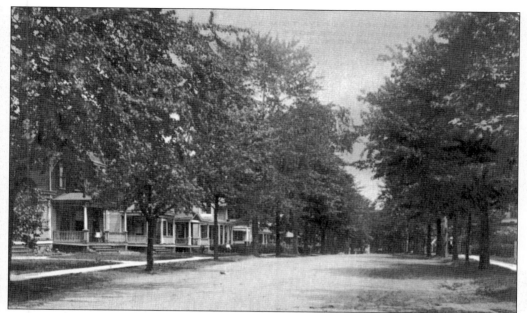

DeMott Avenue is seen in this view looking west from Second Street. (Courtesy of the Mark S. Auerbach Collection.)

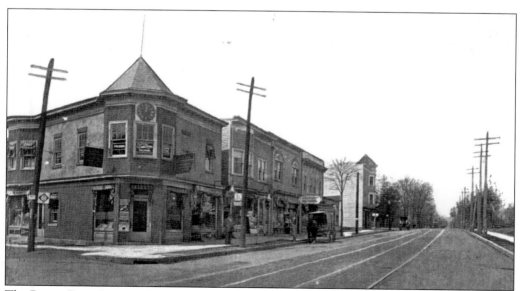

The Berger Drug Store and Thorburn's Hall are pictured in this pre–World War I scene of Main and Clifton Avenues. (Courtesy of the Van Dillon Collection.)

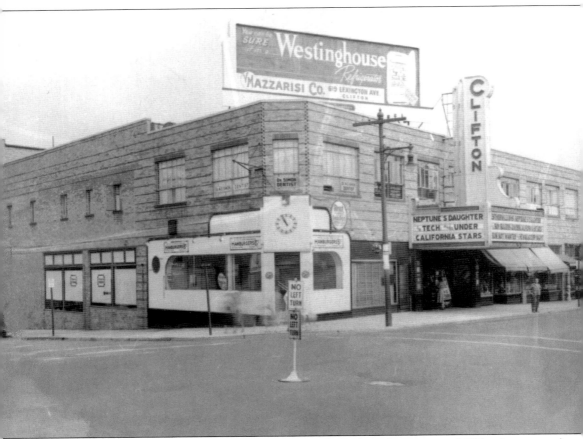

The Clifton Theater was showing *Neptune's Daughter* when this picture of Clifton's crossroads was taken. The 1949 musical starred Esther Williams and Red Skelton in a tale of a romantically cynical young woman and the man who changes her point of view. The Oscar-winning score included the song "Baby It's Cold Outside." At the theater's opening in 1937, *Emile Zola* starring Paul Muni and *Double or Nothing* starring Bing Crosby was the double-feature, with a trailer on the sinking of the U.S. gunboat *Panay* by the Japanese. (Courtesy of the Mark S. Auerbach and Van Dillon Collections.)

Three
THE BEST YEARS
OF OUR LIVES

Nine will shine tonight, Nine will shine.
She'll shine in beauty bright, all down the line.
Won't we look neat tonight, dressed up so fine.
When the sun goes down and the moon goes up, Nine will shine!
All of the students, they are so fine. They are the pride of School Number Nine.
They always try to work at their best.
And we always know that Nine will go, 'Way above the rest!

—Sung at many assemblies at
School No. 9 in Allwood

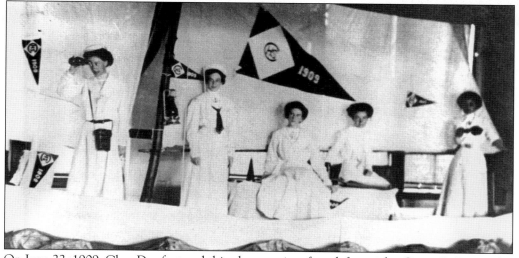

On June 22, 1909, Class Day featured this play, starring, from left to right, Grace C. Burroughs, as the lookout; Mabel A. Libbey, as the captain; Nellie M. Brown, as the wireless operator; Bessie G. Velders, as the man-at-log; and Agnes B. Weller, as the first mate. *The Last Voyage of the Naughty Nine* featured these vocal selections from the crew: "Mermaids' Evening Song," "Larboard Watch," and "Song of the Sea." The high school orchestra and the girls' glee club also performed. (Courtesy of the Clifton Public Library.)

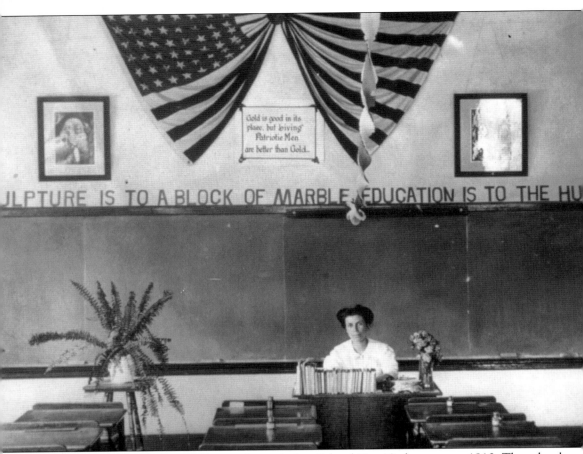

Schoolteacher Martha Wallace is shown in her School No. 10 classroom *c.* 1910. The school, at Clifton Avenue and First Street where a municipal parking lot now stands, was a center of activity. The high school was on the second floor, with lower grades downstairs. When the first class of Clifton High graduated in 1909, the handful of students in the class—all girls—performed *The Last Voyage of the Naughty Nine*. Appropriately, the captain was played by class valedictorian, Mabel Libbey. (Courtesy of Clifton Public Library.)

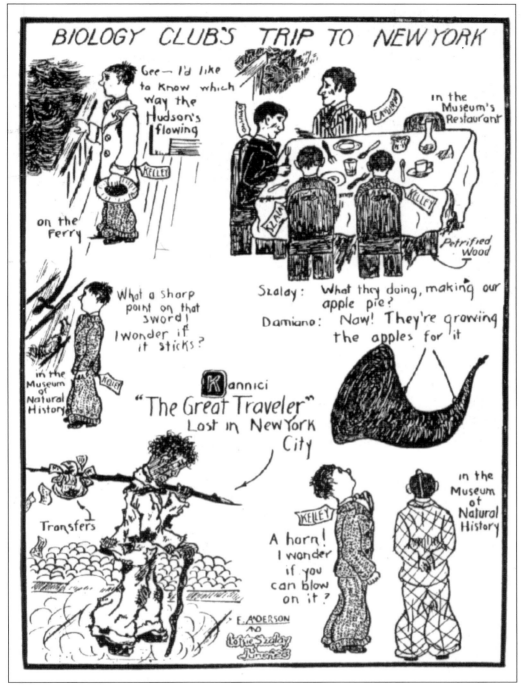

Not much has changed since this Clifton High School biology class of the 1920s went on a field trip to the Museum of Natural History. Clifton's proximity to New York City still makes for plenty of field trips.

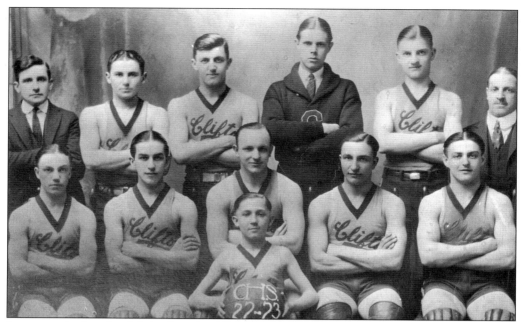

It was no doubt a hard fight, but the 1922–1923 version of Clifton High School's basketball team lost to the "wonder team" from Passaic in a 36-34 match at the Paterson Armory. It was Passaic's 112th straight victory in a streak that ended with 159 wins. Seen in this photograph are, from left to right, the following: (front row) Emil Bondinell, Joseph Tarris, Ray Bednarski, Vincent Chimenti, Art Argauer, and Pete Wilhovsky (mascot); (back row) Harry J. Collester (coach), Morris Karp, Larry DeMattia, Donald Welenkamp (manager), George Reasor, and Walter F. Nutt (principal). (Courtesy of Clifton Merchant.)

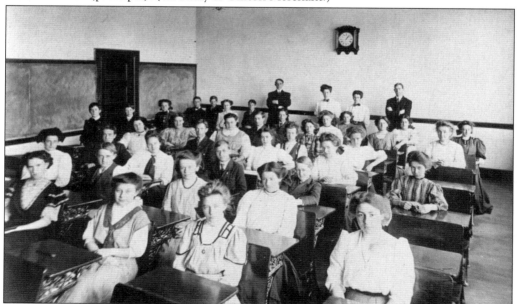

In 1908, the entire student body of Clifton High School could fit in one classroom. (Courtesy of Clifton Public Library.)

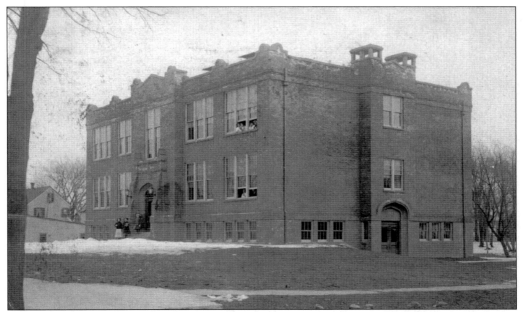

"This is the new Clifton High School, which was opened last September," wrote the author of this postcard message to a friend in Winston, England, in April 1908. Before too many years, a third floor and wings were added to the school, at Clifton Avenue near First and Main. By the mid-1920s, the high school moved to land located off old Route 6, today's Route 46, and School No. 10 again became a grade school. (Courtesy of the Mark S. Auerbach Collection.)

SCHOOL NO. 10, CLIFTON AVE., CLIFTON, N. J.

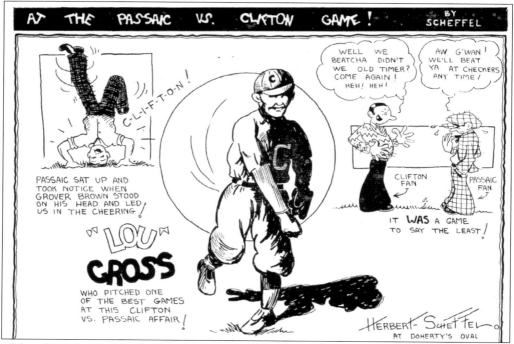

Clifton High baseball games were played at Doherty's Oval in the 1920s. Here, teammate Lou Cross's exploits are featured in what was a typical Clifton-Passaic rivalry. This illustration appeared in the June 1926 issue of the high school's yearbook, *The Reflector*.

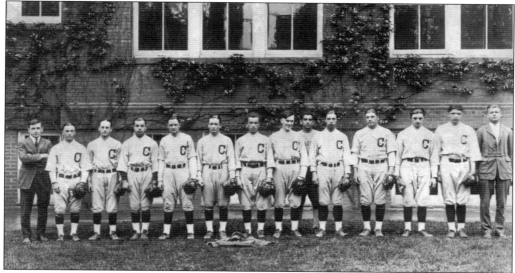

The Clifton High School baseball team of 1924 lines up outside the school, at Clifton Avenue and First Street, for this photograph. Shown, from left to right, are Harry Collester (coach), Emil Bondinell (captain), Emil Bednarcik (who later served for decades as a Clifton coach), Ernest De Lorenzo, Nick Perzel, George Young, Joseph Puzio, Louis Cross, Ernest Tomai, Bill Dobbelaar (later a longtime Clifton teacher), Phil De Lorenzo, Alfred Moro, George Barna, and John Mikulik (manager). (Courtesy of Clifton Merchant magazine.)

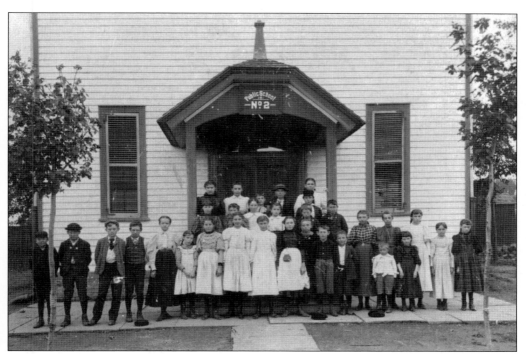

The wooden version of School No. 2 on the western leg of Van Houten Avenue served Richfield students. The school, one of a couple of wood versions, is shown here in an updated class picture. Its brick replacement, erected at a cost of $600,000, was dedicated in 1949. (Courtesy of Clifton Public Library.)

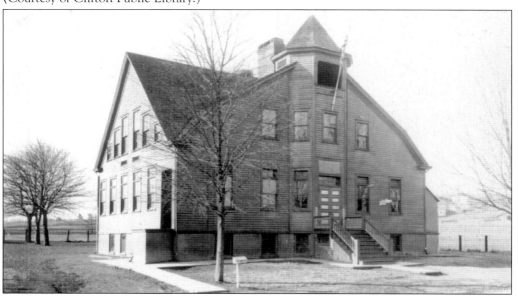

Public School No. 3, on Clifton Avenue between First and Second Streets, is perhaps Clifton's oldest school still standing. Teacher Josephine Hoch, who commuted to work from Somerville, is shown with her charges *c.* 1904. The children had a fondness for the circus, which would visit

the site of the present-day Main Memorial Park. A newspaper item on May 27, 1905, read: "School # 3 was closed Thursday afternoon on account of the circus. The attendance was slim in the morning." (Courtesy of Clifton Public Library.)

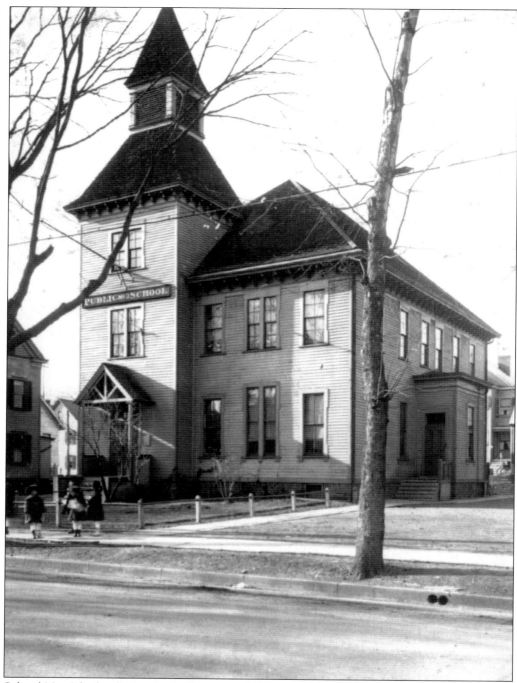

School No. 3 had a distinctive bell tower *c.* 1920. After classes moved to the new School No. 3, on Washington Avenue, *c.* 1933, the Reverend George B. Grambs of nearby St. Peter's Episcopal Church made several "begging visits" to the Clifton Board of Education, which voted to give the old bell to the church in 1935. The bell, weighing 450 pounds, now rings each Sunday in the tower of the *c.* 1966 church. (Courtesy of the Van Dillon Collection.)

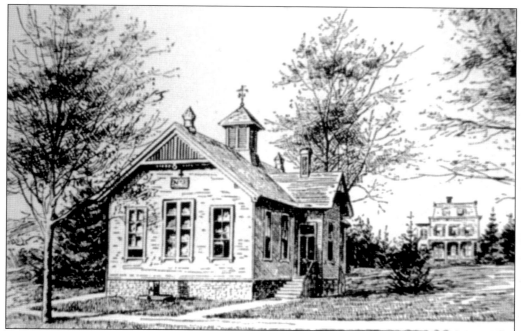

The forerunner of School No. 3 was constructed in 1876, with additions constructed in the 1890s at First Street and Clifton Avenue. (Courtesy of Clifton Public Library.)

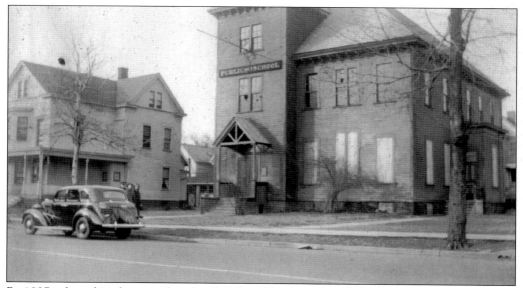

By 1937, when this photograph is dated, School No. 3 was boarded up and condemned. Shortly afterward it opened as the city hall annex, where groups such as the Environmental Protection Commission conducted meetings. Today, the building houses offices. (Courtesy of Clifton Merchant Magazine.)

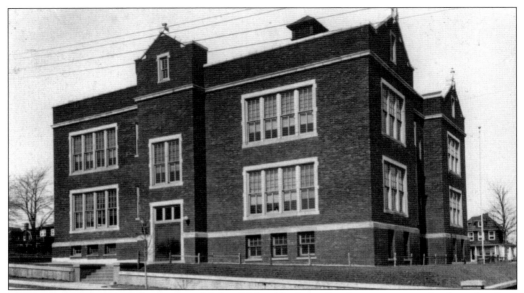

There were various wood versions of School No. 4 before a brick structure was built on land on West Second Street. The bell from the predecessor school, at South First Street and Sixth Avenue, was incorporated into the new school only to come crashing through the roof when a fire gutted the building in 1929. The school was rebuilt using the original plans and was known as Clifton's smallest elementary school. (Courtesy of John Forstmann Library and the Van Dillon Collection.)

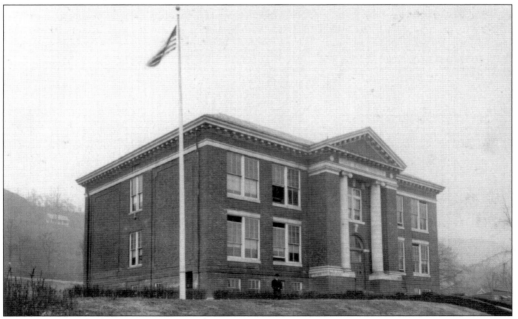

In 1912, a new School No. 5 was built in the Albion section, along what is today's Valley Road. The road was a thoroughfare along Garret Mountain that connected Paterson in the north to Essex County in the south. The school is shown here c. 1920. (Courtesy of John Forstmann Library and the Van Dillon Collection.)

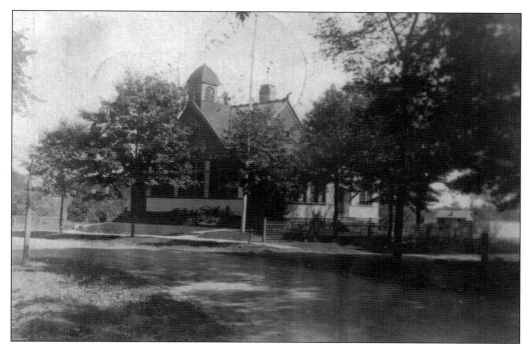

The original School No. 6 was built in 1890 on Claverack Road, now Clifton Avenue, and had a cupola to house the school bell. The pull rope hung through the ceiling into a classroom, where boys would scramble to ring it. In a 1905 postcard (above), there is a notation describing the school as the "Temple of Knowledge." In 1912, a brick school (below) was built along the north end and, in 1930, the wooden structure was razed. Declining enrollment led to the decision to close the school in 1962. Today, the building is used as offices for the Clifton Board of Education. (Courtesy of the Van Dillon Collection.)

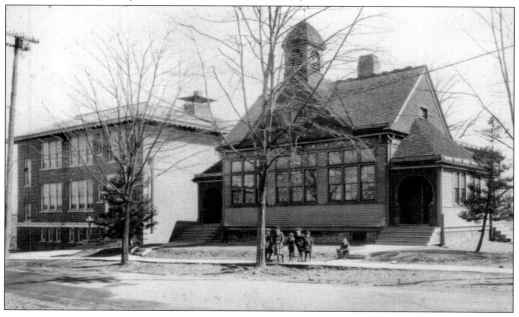

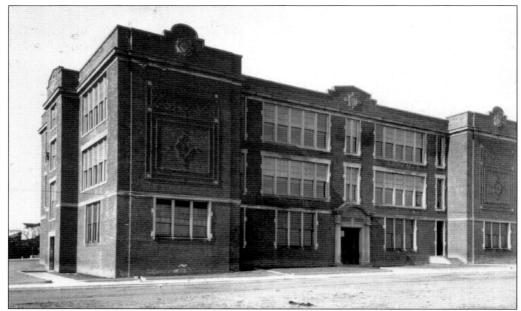

School No. 7 stood at Parker Avenue near Ackerman Avenue, and it was a magnet for children from newly arrived immigrant families. In 1955, the school was converted into a junior high school for a time. It was torn down in 1965, after being abandoned. (Courtesy of the John Forstmann Library and the Van Dillon Collection.)

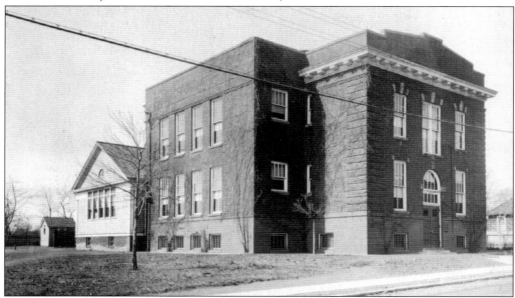

An item about School No. 8 pupils was found under the heading "Delawanna" in the newspaper in 1905. "Principal E. Kelly of School #8," it read, "recently caught several boys at the golf links that should have been at school. He threatened to send them to jail, but they promised to attend school regularly and were allowed to go." A six-room brick addition was added to the front of the wooden schoolhouse, which was in use from c. 1914 to 1925. (Courtesy of the John Forstmann Library and the Van Dillon Collection.)

Finding a place for School No. 9 was not easy. In May 1905, members of the Acquackanonk Township Board of Education paid a visit to meet the citizens of Allwood and see whether the ground was suitable. A newspaper article of the event read: "The citizens of Allwood got up early and fed their ducks, gathered their eggs and changed their clothes and were all waiting at the depot when the members of the board arrived." Once at the location, the people of Allwood "threw off their coats and began to dig up the ground" to prove a point and satisfy the board. What did they leave behind? Holes from six to eight feet deep all over the property. (Courtesy of the John Forstmann Library and the Van Dillon Collection.)

Since School No. 11, on Merselis Avenue, in the Lakeview section, was surrounded by pasture in 1907, its dismissal times were sometimes delayed until a teacher or janitor could chase cows away from the doorstep, according to Marjorie Drahos, a longtime Clifton teacher who once chronicled the city's schools. The building was a two-room brick schoolhouse then. By 1912, a six-room addition had been built, followed by a 16-room addition in 1926. In the early days, field mice were another problem, even finding their way into coat sleeves in the cloak rooms. (Courtesy of the John Forstmann Library and the Van Dillon Collection.)

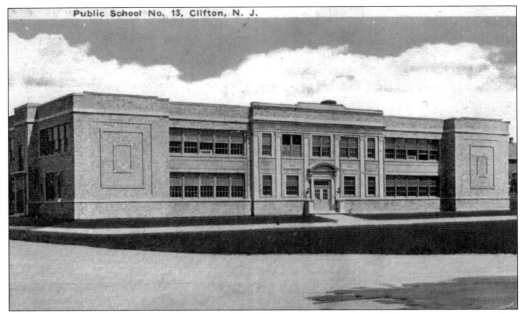

Clifton's School No. 13 was built on Van Houten Avenue in 1923, the same year that School No. 15 on Gregory Avenue was built, using similar plans. (Courtesy of the Mark S. Auerbach Collection.)

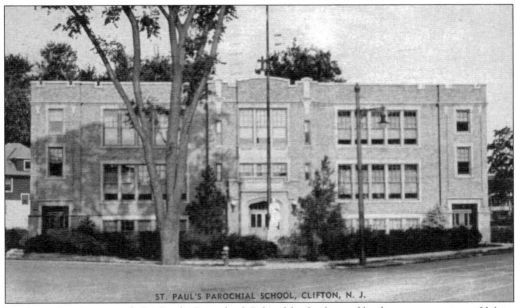

ST. PAUL'S PAROCHIAL SCHOOL, CLIFTON, N. J.

In this *c.* 1940 postcard, St. Paul's Parochial School had a line of bushes at its corner of Main and Washington Avenues. It was founded in 1916 by the Sisters of Charity and was moved to its current location in 1926, after a four-year building process. It first graduating class had five students. (Courtesy of the Mark S. Auerbach Collection.)

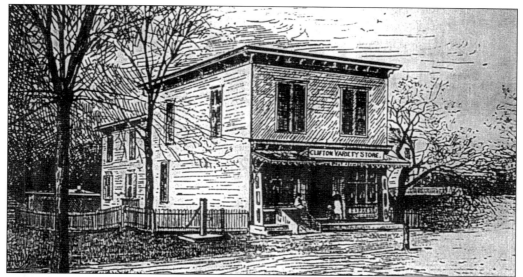

It was a post office and variety store downstairs, but on the second floor of McDaniel's Hall, both public and parochial students got their start on Getty Avenue. This illustration was made just a couple years before it became the birthplace of a church school for St. Paul's Episcopal Mission, later known as St. Peter's. In fact, the church's first service was conducted at this site on November 18, 1896. (Courtesy of the Clifton Public Library.)

Some students of St. Peter's Episcopal Church School stood outside the parish hall on Clifton Avenue many years later, in 1935. Seen here, from left to right, are William Henry, James Jeffcoat, Robert Strayer, Helen Skrine, Don Fischer, and Warren Kyse. (Courtesy of Vince and Alice Dymek.)

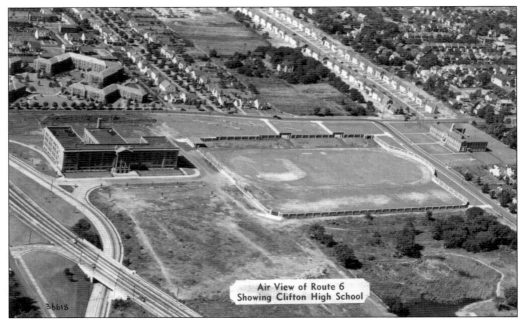

Air View of Route 6
Showing Clifton High School

36618

The "new" Clifton High School, which opened in 1926 and today serves as Christopher Columbus Middle School, is seen along what was Route 6. Clifton purchased the former racetrack property along Main and Piaget Avenues for school purposes in 1920. The walls to the present-day Clifton school stadium are visible from the aerial view. It was not until October 1950 that the 7,200-seat stadium was officially dedicated, with a pageant depicting the site's first Indian inhabitants, who were followed by the early Dutch settlers, and then by racehorses of the Clifton Racetrack. Finally, the field was used for breaking mustangs. (Courtesy of the Mark S. Auerbach.)

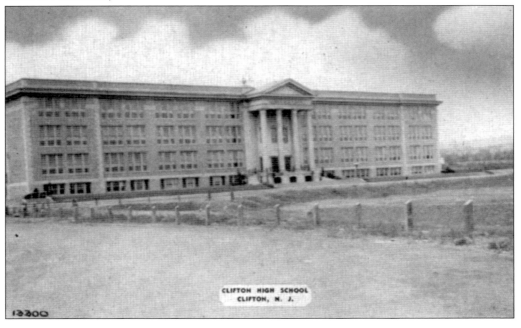

CLIFTON HIGH SCHOOL
CLIFTON, N. J.

13300

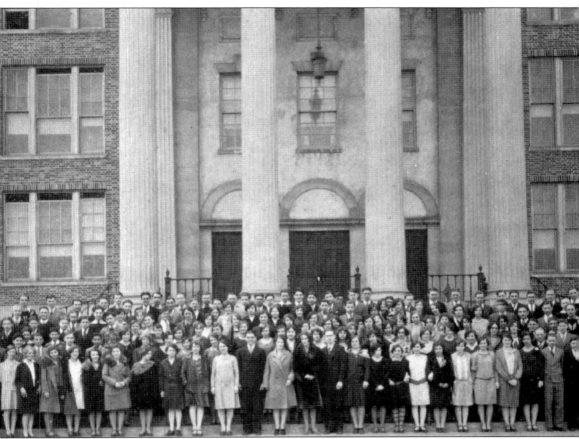

The Clifton High School Class of 1930 poses on the steps of the school in a portrait in the 1929 yearbook, which features individual pictures of the graduates. During a recessional ceremony for the seniors, they could be heard saying these words: "Old Clifton faces, Old Clifton places, Tho' we parted far a-way, Seen ever clearly, lov'd ever dearly, Shall then be with us as today; Each hall familiar, each dear old custom. Each comrade loyal to our school." After taps were played, the graduates said: "So good-bye, Clifton High, Alma Mater, Our dear Clifton High, And to you we'll be true Clifton High."

By 1962, an ever newer Clifton Senior High School had risen along Colfax Avenue, with wings for each of its three grades. Today, the high school accommodates grades nine through twelve. With the addition of a new wing, Clifton High School is the second largest high school in New Jersey. In the 1962 yearbook, the *Columns*, the graduating class is aware that its school, the 1926 version along Route 46, was passing into history. "To others it may appear only a building," it read, "but to us, the graduating class of 1962, it is a symbol representing our education, social acceptance, and unique spirit. We cherish the memories it holds for us." (Courtesy of Clifton High School.)

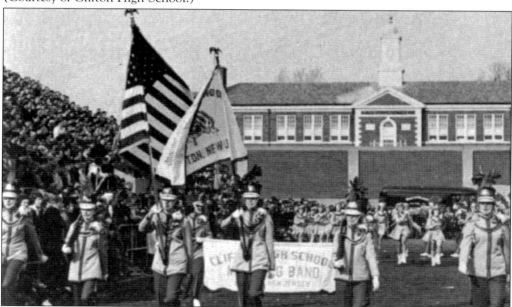

In 1962, the Clifton High School Mustang Band was well on its way to becoming, as it is known today, the high-stepping "Show band of the Northeast." Here the color guard leads the band at a game, with School No. 1 visible in the background. That year, the band appeared on television during the "Game of the Week," and was invited to appear in the World Music Festival in Holland. In the band were 80 bandsmen, 16 majorettes, 8 color guard, 2 banner guards, and 1 drum majorette. (Courtesy of Clifton High School.)

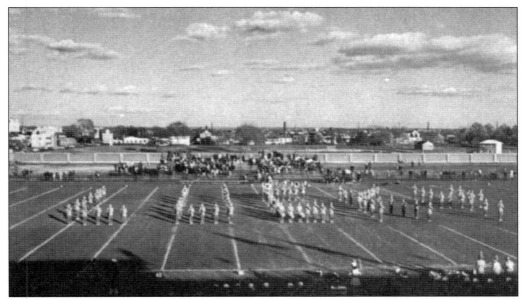

In the early 1960s, the band spells LUCKY on the field as seen from the top of the stands. In subsequent years, its numbers would approach 200. Surviving recruits from the August training sessions got T-shirts saying "I Survived Band Camp."

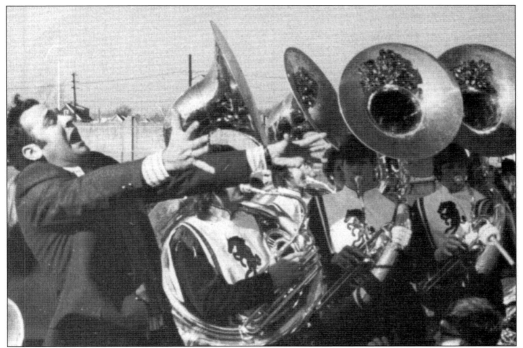

In its 1972–1973 season, Mustang Marching Band members get an earful from band director Robert Morgan as he puts his heart and soul into the band, something he continues to do in the 21st century.

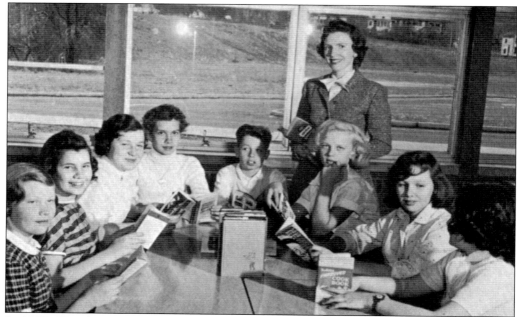

In 1957, Woodrow Wilson Junior High (below), on Van Houten Avenue, was a brand-new school headed by Principal John Mullin and Vice Principal Aaron Halpern, later principal of Clifton High. Something else was new that year, as noted Carol Fisher of that year's class: "Our new report cards took on a new look, different from any previous ones," she wrote in a review of the year. "Their color is green, a good match for the complexion of the students receiving them." Among the many clubs is the Teen Age Book Club, shown here. (Courtesy of Woodrow Wilson Middle School.)

Four
BUSINESS AS USUAL

Strenuous, their labors brought forth fruits of joy;
Working with good neighbors, talents they'd employ.
To create a hamlet – then a town of size –
Finally a city CLIFTON, which we prize.

—Ernest T. Scheidemann, Clifton's poet laureate
from the poem "Participation"

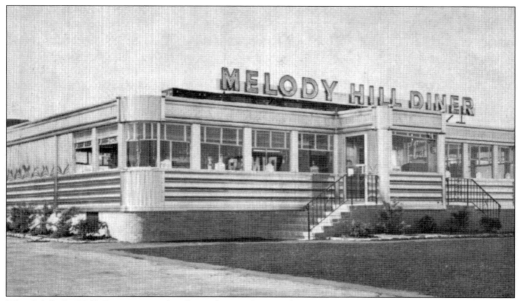

The Melody Hill Diner once beckoned travelers with these words: "Pleasant and comfortable spot to enjoy a short snack or full course meal—on North Jersey's most traveled thoroughfare, U.S. Highway 46." In later years, it became home to Gino's and then a Roy Rogers restaurant, and more recently a Boston Market. (Courtesy of the Mark S. Auerbach Collection.)

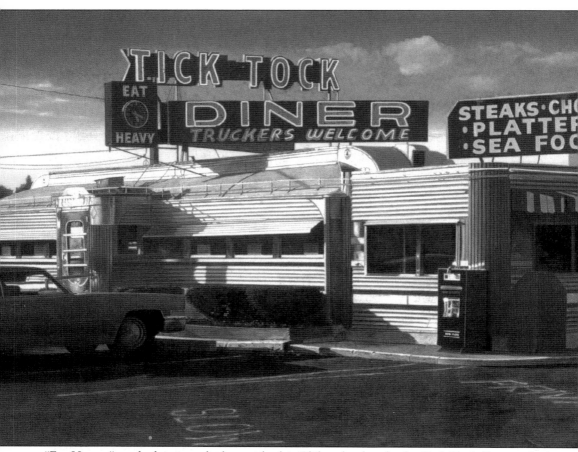

"Eat Heavy," reads the time clock outside this Clifton landmark, the Tick Tock Diner, which still operates along Route 3 westbound in its third incarnation. The predecessor of the 1994 version is known as Mays Landings Diner, along New Jersey's Route 35, after literally being moved south. The current owners—Steve Nicoles, Alex Sgourdos, and Billy Vasilopoulos—have been at the helm since 1986. (Courtesy of the Mark S. Auerbach Collection.)

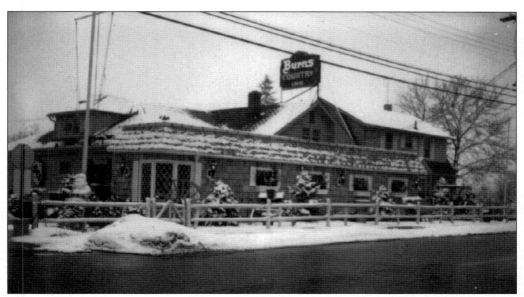

The Burns Country Inn, on Valley Road and Robin Hood, was a Clifton institution that operated from 1958 to 1984. The above picture shows the restaurant before an expansion in 1971. Below, is an interior view. The site was the locale of many special events, including this author's wedding rehearsal dinner in 1979. It was run by Harry Burns Jr., whose father, Harry Burns Sr., ran the Burns Steakhouse on Piaget Avenue until 1962. Today, the building is the Belvedere Restaurant. "A couple blocks from the racetrack, it was all farms," Burns Sr., now 97, said of those days at the steakhouse. His grandson Kyle Burns ran Pathway to Health at the Clifton Plaza shopping center for 17 years, through the 1990s. (Courtesy of the Burns family.)

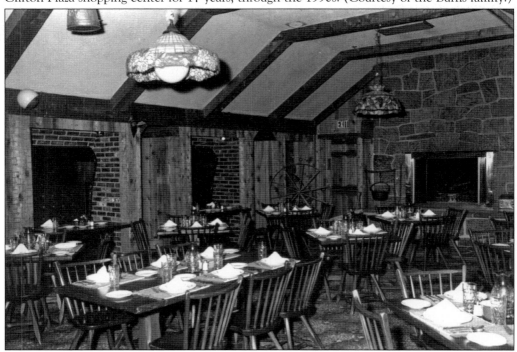

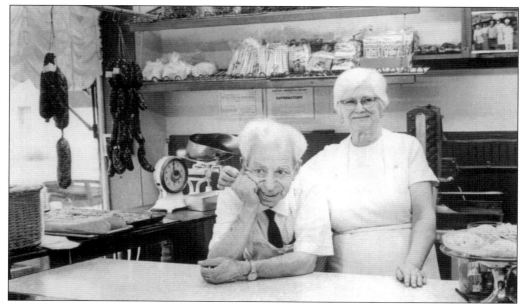

Fresh pasta and a white-haired woman whose true joy in life was to "wait on customers" could be found on Botany Village's Parker Avenue, home to a shop called Maria's Ravioli. There, Maria Leonardi and her husband, Leonardo Leonardi, ran the family business, starting in 1953. It relocated to Wayne in 2000. (Courtesy of Jennifer and Joe Leonardi.)

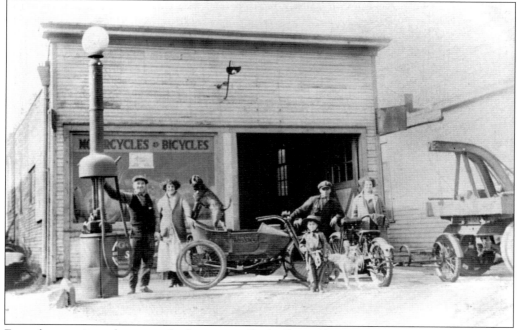

Even dogs got into the act at the Lexington Cycle Shop. Shown in this *c.* 1924 image, at 509 Lexington Avenue, are, from left to right, Ernest Tramontin, Pierina Tramontin, "Jimmy," Arthur "Bub" Tramontin, Joseph and his dog, and Ida Tramontin, Joseph's wife. (Courtesy of the Clifton Public Library.)

The newspapers of the 1920s tout their news-gathering resources in their bid to drum up readership.

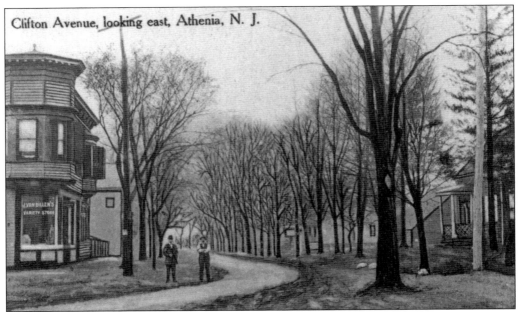

Van Dillon's Variety Store (above) stands on this country corner, at Elm Street and Clifton Boulevard in the Athenia section. The store, which opened c. 1883, traces its roots to the days of David Van Dillon's grandfather, who used a cart for sales. "He would call out his wares," said Dorothy Van Dillon, David's widow. The hotel across the street (below) was also adjacent to the railroad tracks. (Courtesy of the Van Dillon Collection.)

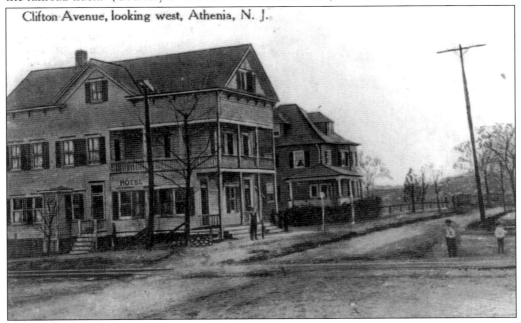

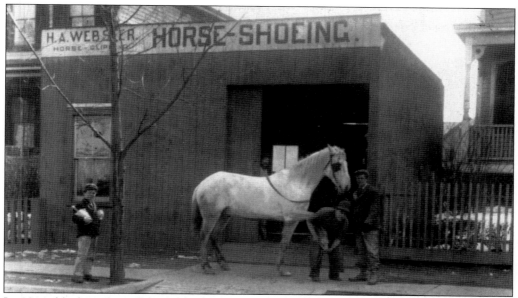

In 1914, blacksmiths still had a steady source of income, as evidenced by the shop of H.A. Webster, located on Highland Avenue between Main and Second Street. (Courtesy of the Van Dillon Collection.)

For all the horses put to work pulling barges along the Morris Canal, there was the blacksmith shop of Jacob Fishbach, across from the Doremus House on Broad Street near Van Houten Avenue. The canal operated from 1824 to 1924. (Courtesy of the Clifton Merchant Magazine.)

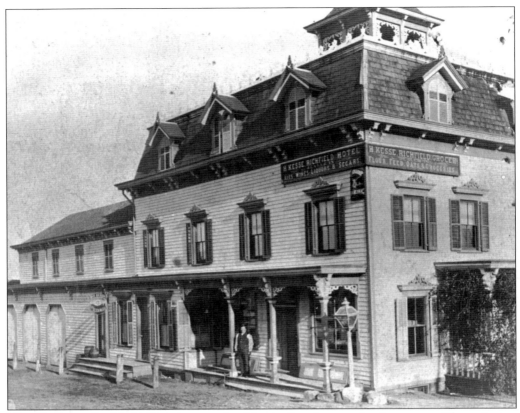

The H. Kesse Richfield Hotel, near the Morris Canal, was also known as Cheap Josies. (Courtesy of the Van Dillon Collection.)

At 17–19 Ackerman Avenue stood the Blue Danube, an "open-air beer garden" run by Rudolph and Gertrude. It offered "German cooking, choice wines, liquor, beer, entertainment." (Courtesy of the Mark S. Auerbach and Van Dillon Collections.)

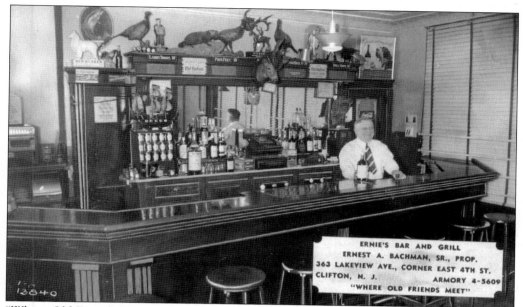

ERNIE'S BAR AND GRILL
ERNEST A. BACHMAN, SR., PROP.
363 LAKEVIEW AVE., CORNER EAST 4TH ST.
CLIFTON, N. J. ARMORY 4-5609
"WHERE OLD FRIENDS MEET"

"Where Old Friends Meet" is the boast on this postcard featuring a Lakeview Avenue tavern. (Courtesy of the Mark S. Auerbach Collection.)

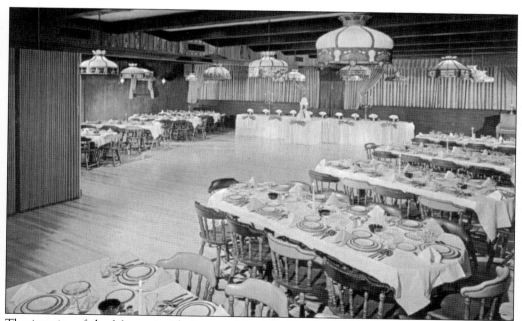

The interior of the Mountainside Inn, on Hazel Street, shows tables set for a wedding. "Early Americana accented by personal gracious service," notes the wording of this undated postcard. (Courtesy of the Mark S. Auerbach Collection.)

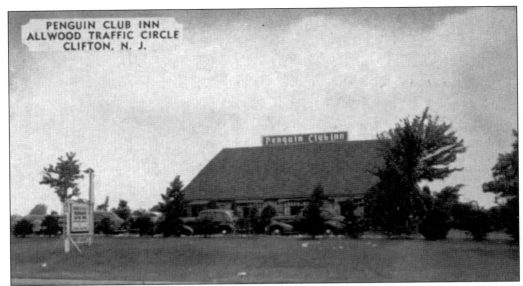

"Dine and dance at the SHOWPLACE OF PASSAIC COUNTY. Special facilities for all social occasions," reads the postcard for the Penguin Club Inn, at the Allwood Circle. Today, it is home to Rick's Sports Bar. (Courtesy of the Mark S. Auerbach Collection.)

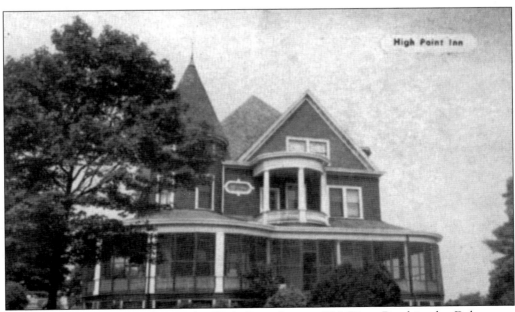

Originally a 19th-century home, the High Point Inn, at 204 River Road in the Delawanna section, was a popular bar and dining room suited for weddings and large parties. (Courtesy of the Mark S. Auerbach Collection.)

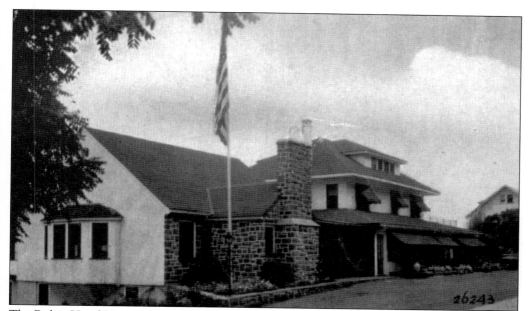

The Robin Hood Inn on Valley Road was a Clifton institution, home to many a political event. Its decor, with Sherwood Forest themes, boasted a piano where legend has it that Herman Hupfeld composed "As Time Goes By," recorded by Rudy Vallee in the 1930s. The composition was the signature song for the 1942 film *Casablanca*, starring Humphrey Bogart and Ingrid Bergman. (Courtesy of the Mark S. Auerbach Collection.)

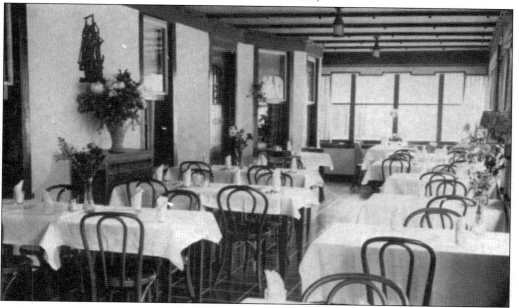

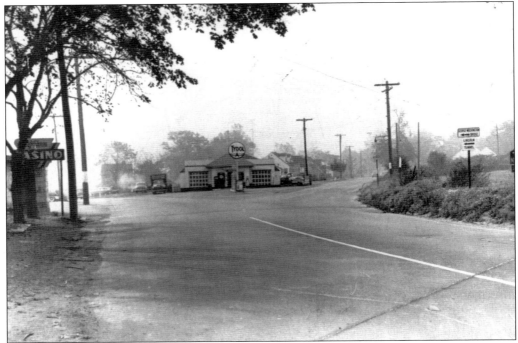

The sign for Clifton Casino can be seen on the left of the above photograph showing the B.E. Beckman Service Station, where Broad and Grove intersect north of Van Houten Avenue. The interior, shown below, had suitable "accommodations for banquets." (Courtesy of the Van Dillon and Mark S. Auerbach Collections.)

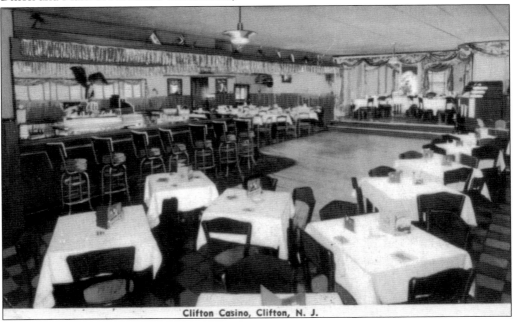

Clifton Casino, Clifton, N. J.

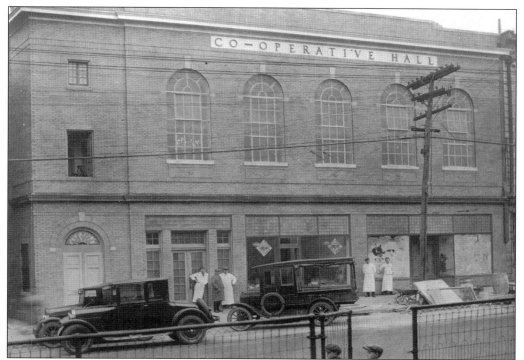

In Clifton's Botany Village section, the Co-operative Hall was home to the Italian-American Family Association and the Cooperative Grocers during the 1920s. The site, at 282 Parker Avenue, also was the host of social and sporting events. (Courtesy of the Van Dillon Collection.)

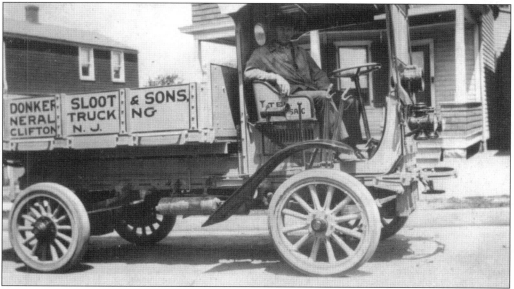

Seen here is Matt Donkersloot of Donkersloot & Sons aboard the family's truck. The sand, grave, and stone company has been in business since 1902, operating from Second Street. (Courtesy of the Van Dillon Collection.)

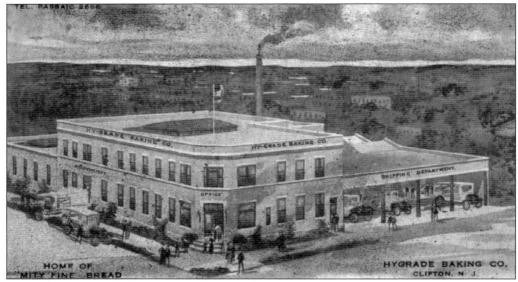

The Hygrade Baking Company of Clifton was the maker of Mity Fine bread. (Courtesy of the Mark S. Auerbach Collection.)

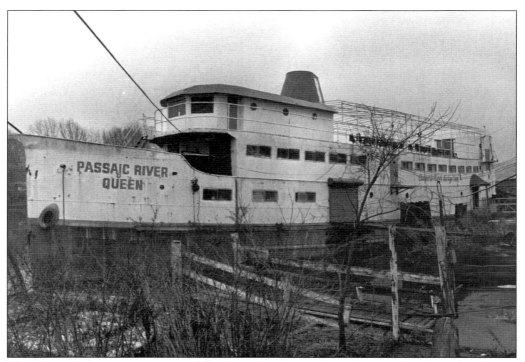

This Great Lakes steamer, moored by River Road, was brought to Clifton by Alex Komar c. 1970 and was operated as a restaurant known as the Passaic River Queen for about four years before it broke its moorings and ended up downriver. (Courtesy of the Clifton Merchant Magazine.)

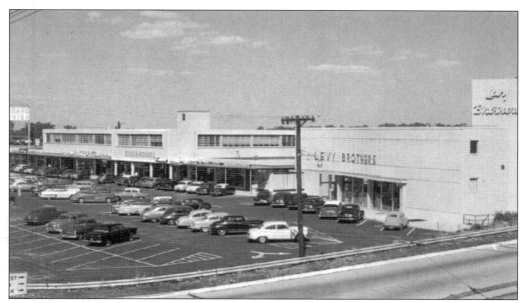

Levy Brothers was the anchor of the Styertowne Shopping Center. It opened in May 1952, featuring a welcoming breakfast for Clifton officials and guests. Today, the Rowe-Manse Emporium is the anchor. (Courtesy of the Mark S. Auerbach Collection.)

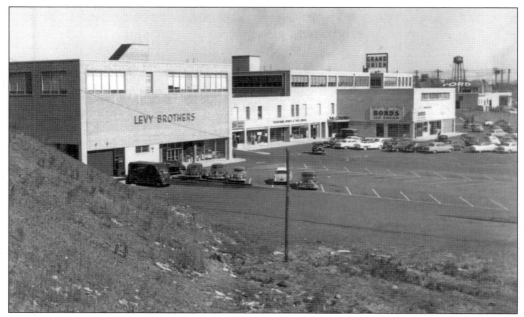

The rear of Styertowne was home to Bond's Ice Cream, a place frequented by young people and fondly remembered for its large Awful Awful shakes. (Courtesy of the Clifton Merchant Magazine.)

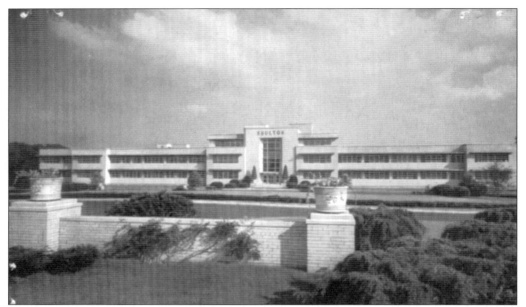

The maker of Old Spice cologne came to Clifton in 1946, when Shulton Incorporated opened its executive and manufacturing buildings (above) at Colfax Avenue and Route 46. "The recently completed Shulton plant stands on a 33 acre site on one of the main highways of the New York metropolitan center . . . an outward symbol of the fine acceptance of Shulton products," read a postcard. The inside of the plant was graced by a mural called *Womanhood through the Ages* (below). The work, said a postcard of the time, "pays scented tribute to Venus, Goddess of Beauty." The mural was 114 feet long, 11 feet high, and contained 40 colorful figures in heroic size. This 20-foot section featured a "stately beauty" from the court of Louis XIV, a "charming Hindu," a veiled Arabian, and a "Gay Nineties belle." By spring of 2001, the last of the concrete was being removed, making way for a 600-unit town house development. (Courtesy of the Mark S. Auerbach Collection.)

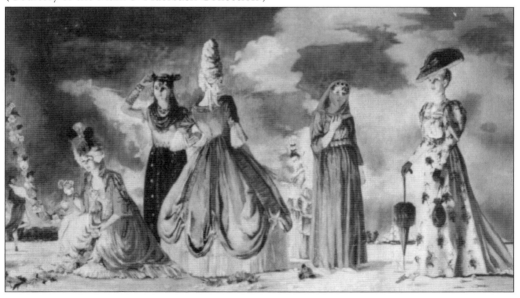

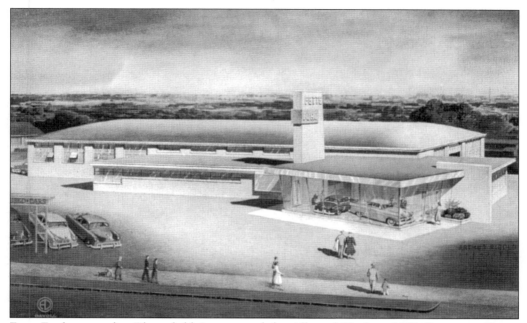

Fette Ford operated at Bloomfield Avenue and the Allwood Circle *c.* 1952. Proprietor Henry Fette was a booster of Clifton, heading up the building committee for the library at the time and later serving as grand marshal of a parade honoring Clifton's 75th anniversary. The dealership is now on Route 46 in a building that once housed a bowling alley. (Courtesy of the Mark S. Auerbach Collection.)

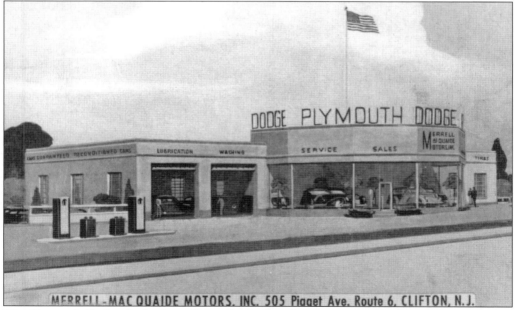

The Plymouth Dodge dealership of Merrill-MacQuaide Motors could be found along Route 6, now Route 46, *c.* 1940. Until recently, the dealership served as an Annie Sez clothing store. (Courtesy of the Mark S. Auerbach Collection.)

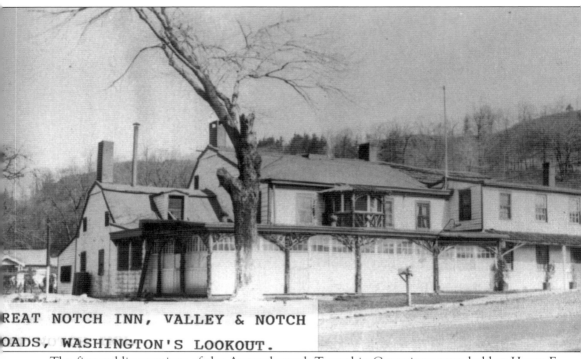

GREAT NOTCH INN, VALLEY & NOTCH ROADS, WASHINGTON'S LOOKOUT.

The first public meetings of the Acquackanonk Township Committee were held at Henry F. Piaget's house in 1840, along Valley Road. There, his Great Notch Inn stood. It operated until it was lost to fire in October 1935. During that first meeting, the town fathers of the predecessor of Clifton did their work, deciding against imposing a new tax on owners of a single dog and approving a $1 charge for each additional dog. They also voted to budget $1,200 for the support of the poor in the coming year and $800 for keeping the highways in repair. The actual notch, in the right rear of the photograph, was said to be a lookout point for George Washington's troops during the Revolutionary War. Today, Gensinger's Motors occupies the location. (Courtesy of the Van Dillon Collection.)

Five
CHURCH AND STATE

*The parish is doing its job of ministering to the needs of the people
in and out of the parish. Even if one person out of all those to whom
we have tried to minister has been helped and the burdens relieved, and
this one has been brought closer to God's mercy seat, then, as scripture
reminds us, "There is more joy in Heaven over one sinner who
repenteth than over the 90 and nine just persons who need no repentance."*

—The Reverend Louis S. Luisa
St. Peter's Episcopal Church, 1958

The Calvary Baptist Church stands on the southeast corner of Clifton and Lexington Avenues
across from Hird Park. This postcard view dates from 1926. In 1909, textile manufacturer
Samuel Hird and his family were among those who severed ties with the First Baptist Church
in Passaic and organized as the Calvary Baptist Church. One of Calvary's rectors, Rev. Lee J.
Beynon, gave the invocation at the dedication of the War Memorial in Memorial Park in 1929.
(Courtesy of the Mark S. Auerbach Collection.)

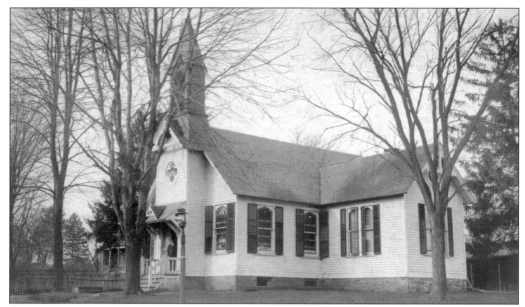

The old Athenia Reformed Church on Clifton Avenue, near Colfax Avenue, had its beginnings in 1882 under the leadership of Hugh Cheyne, treasurer of the Singer Sewing Machine Company. The original wood church was replaced in 1951 with a brick structure, which still serves the congregation today. In 1957, a wing of classrooms was added for an expanded Sunday school. (Courtesy of the Libbey and Van Dillon Collections.)

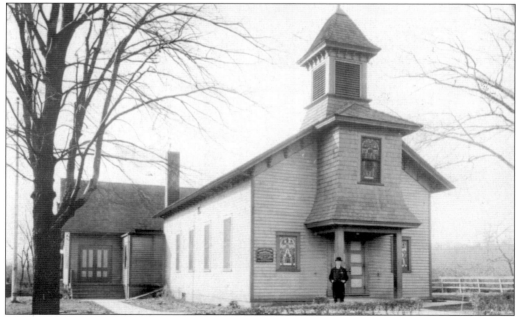

This c. 1920 photograph shows that St. Clare's Roman Catholic Church has incorporated Acquackanonk Township School No. 1. The school and the church stood at the eastern end of Allwood Road. In 1920, the U.S. census listed 26,470 residents. (Courtesy of the Van Dillon Collection.)

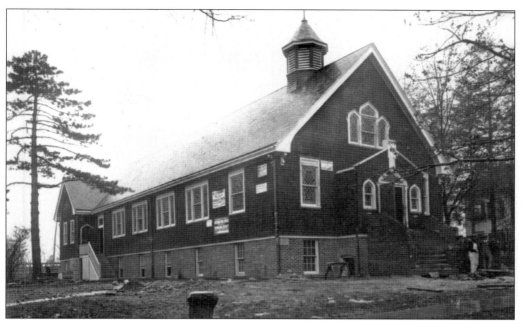

The old St. Paul's Roman Catholic Church (above) stood at Union Avenue and Second Street from 1915 to 1937. In 1938, the cornerstone was laid for the new Gothic stone church, shown below in a 1964 postcard. The so-called Marcy property was purchased in 1915 for $5,800. A house that stood on the property was sold for $125 and removed to Washington Avenue. (Courtesy of the Van Dillon and Mark S. Auerbach Collections.)

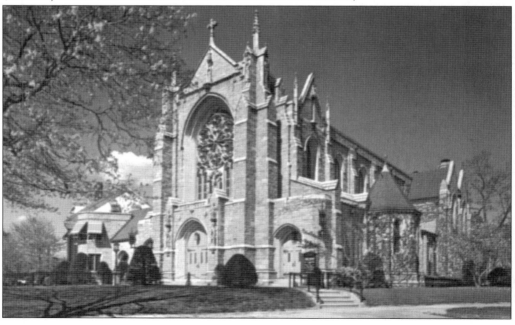

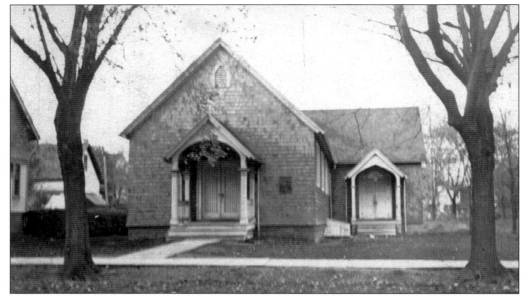

The 1899 version of St. Peter's on Clifton Avenue served the parish until 1966, when a new church rose on the site. The view above shows the church before the addition of the parish hall in 1921 and before the addition of a bell tower. In the view below, from the 1940s, the old rectory is visible on the left. That house is now St. Peter's Haven for homeless families, an outreach mission of the parish. (Courtesy of St. Peter's Episcopal Church.)

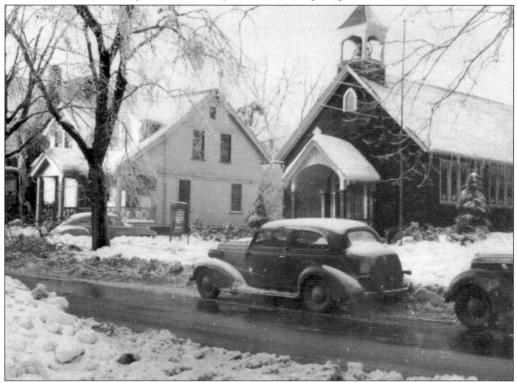

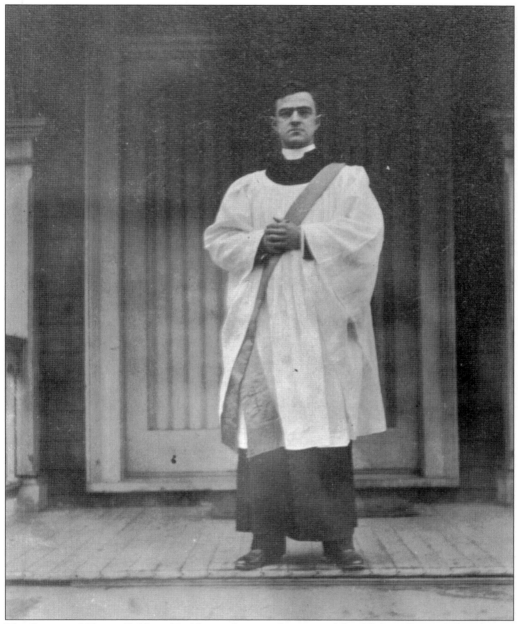

The Reverend Henry Baldwin Todd, standing on the steps of the Clifton Avenue church, was minister-in-charge of St. Peter's, the city's only Anglican parish, when the mission marked its 15th anniversary in 1911. He started as a lay reader, was ordained a deacon on November 6, 1910, and became rector early in 1911. "The communicant list now numbers 84, and the Bible School has increased 50 percent," he wrote. It was a challenging beginning. "There are too few Episcopalians in Clifton to succeed," read a newspaper editorial in 1896. "The few trying to start a church there are placing upon their shoulders a burden that will be oppressive to them for the next 20 years." In 2001, the parish marked its 105th anniversary. (Courtesy of St. Peter's Episcopal Church.)

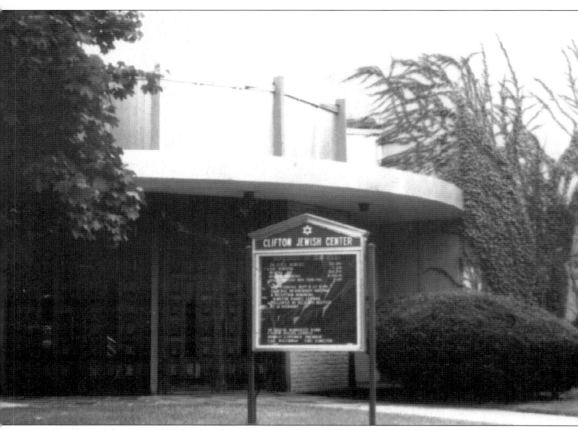

On December 13, 1946, the first services were held at the Clifton Jewish Synagogue at 300 Clifton Avenue, east of Main Avenue, where it received its charter from the United Synagogues of America two years later. The Clifton Jewish Center, shown here at Barclay Avenue, was formally dedicated on November 2, 1952, some three years after Rabbi Eugene Markowitz became the community's spiritual leader. (Courtesy of the Mark S. Auerbach Collection.)

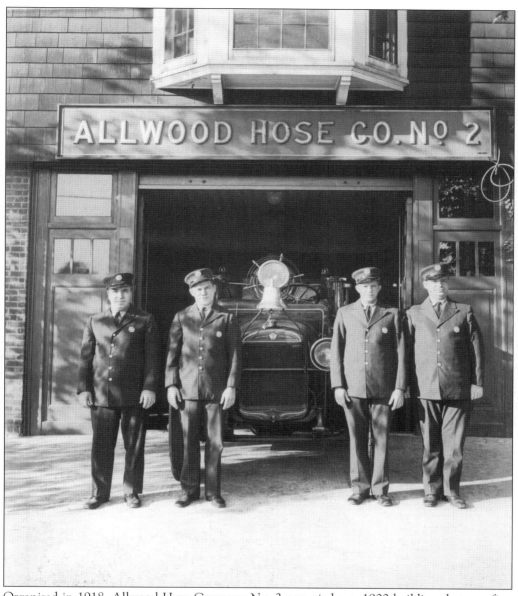

Organized in 1918, Allwood Hose Company No. 2 occupied a c. 1900 building that was first used as the main office of Brighton Mills, across the street. The first floor was a country store for employees in town houses located up the street, where the Allwood branch library and park are today. The second floor served as a community center for dances and meetings. Many Clifton organizations got their start here, including the Allwood Community Church, the Women's and Men's Clubs, and the branch library. Before long, the Knights of Columbus occupied the second floor, followed by a design business of William Hansen, who purchased the building in 1967. Three years later, the firefighters moved up the street to a new building on the other side of School No. 9. The Old Firehouse, as it is called, was restored and remains today largely as it was. (Courtesy of the Clifton Merchant Magazine.)

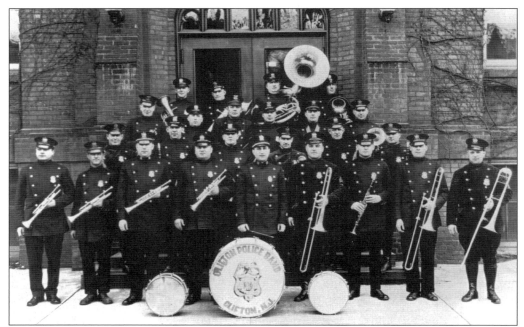

The Clifton Police Band stands on the steps in front of old School No. 10 *c.* 1929. (Courtesy of the Clifton Public Library.)

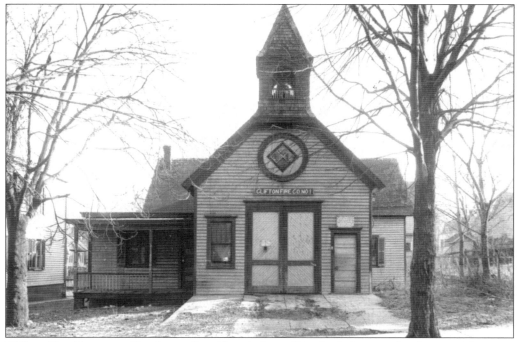

Clifton Fire Company No. 1 stood on Passaic (now Harding) Avenue. Its first president was Colonel Adamson, who was noted in a newspaper mention to have had "many civil activities . . . during his long and useful life in Clifton," which was then part of Acquackanonk Township. (Courtesy of the Van Dillon Collection.)

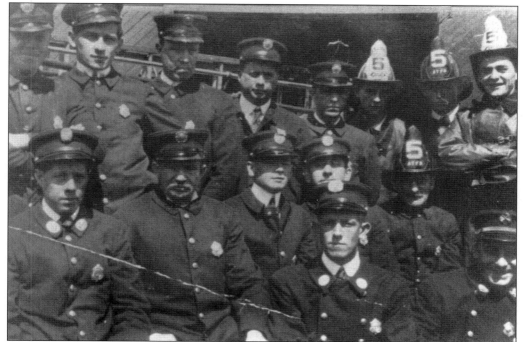

The volunteers of Clifton Hose Company No. 5 were on duty in Dutch Hill in this c. 1915 photograph. The volunteers are, from left to right, as follows: (front row) William Moreland and Charles Lembeck; (middle row) William Speer, Fred Rammoser, "Ire" Speer, unidentified, and Conrad Black, (back row) Aron Van Der, "Terry" Tulip, Charles Rohloff, Cornelius Nederfield, Samuel Speer, and four unidentified firefighters. (Courtesy of the Van Dillon Collection.)

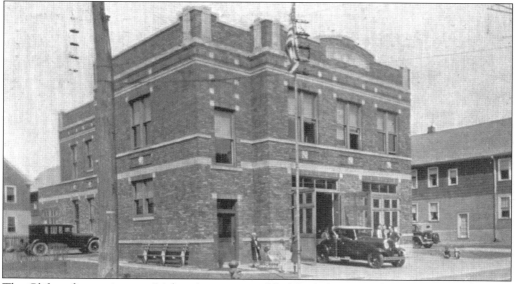

The Clifton fire station, on Mahar Avenue near Hird Park, became Clifton's fire headquarters when it opened on October 16, 1924. (Courtesy of the Mark S. Auerbach Collection.)

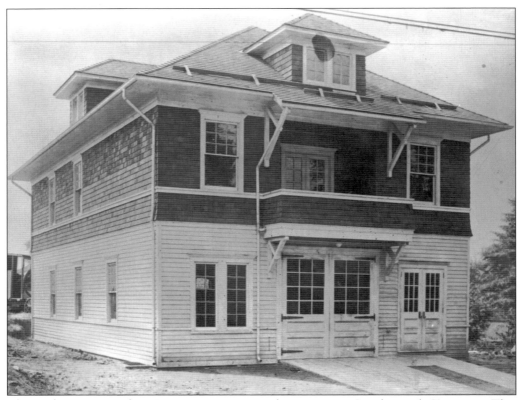

The Lakeview Heights Fire Company stood sentry at Crooks and Trenton. This photograph dates from *c.* 1917. (Courtesy of the Passaic County Historical Society and the Van Dillon Collection.)

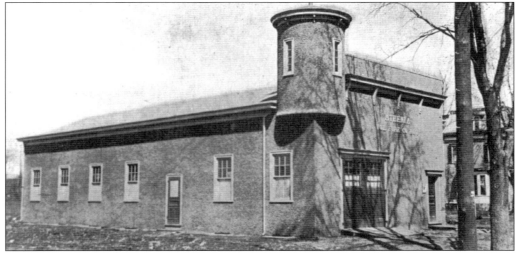

Built in 1912, the old Athenia Volunteer Fire Department No. 7 was on Claverack Road, now Clifton Avenue, and served an important role because of its closeness to the U.S. Quarantine Station for animals. Today, the firehouse is the home of Colonial Pharmacy. (Courtesy of the Clifton Public Library.)

Six

RURAL OUTPOST

He [Carl Lanz] just wanted to hold onto it. My mother and aunt
would always say, "Let's sell! Let's sell!" and it was always, "No, no, no."
The last couple of years of his life, the subject was brought up:
"Dad, what are you going to do when we can't pay the taxes anymore?"
I don't know if it was a good thing, a bad thing, or whatever, but he
passed away before we ever had to come to any sort of conclusion.

—Mary Lanz Parkin, after the 1995 sale of her father's 5.2-acre
family farm and woods, on Grove Street across from School 16

The corner of Broad Street and Allwood Road has changed dramatically since 1940. Today, this juncture, separating the Richfield and Montclair Heights sections, is home to Ploch's Garden Center (left) and a shopping center (right). The photographer was standing roughly where Route 3 runs today, looking north down Broad Street.

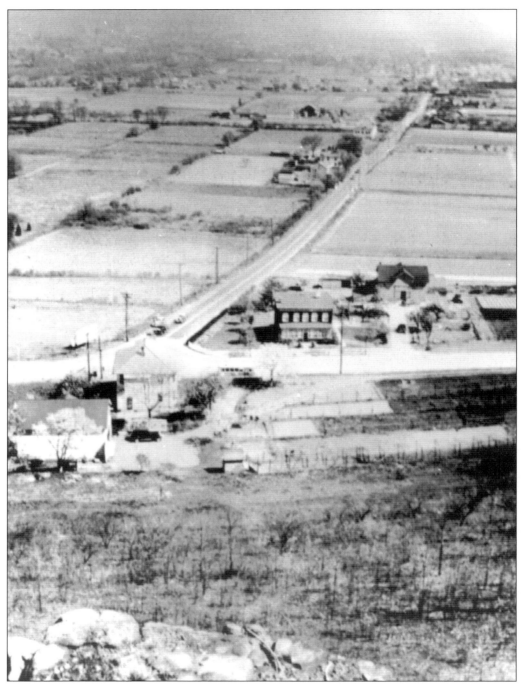

The fields of Clifton are evident in this view high above Valley Road, looking east down Van Houten Avenue. It was taken before Curtiss-Wright homes were built for defense workers in a neighborhood called Acquackanonk Gardens (left), before the Cape Cods of Maple Valley were built (right), and before Woodrow Wilson Junior High School was erected in 1955 down Van Houten (left). (Courtesy of the Clifton Public Library.)

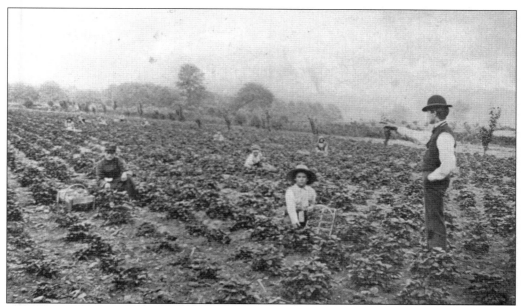

T.C. Kevitt was a strawberry grower whose five-acre crop was harvested south of Mount Prospect Avenue in the Athenia section. In an 1895 article in the *Passaic Daily News*, Kevitt had this to say: "This will give us a yield of 35,000 and 40,000 quarts of berries. Since the 'norther' of May 12th swooped down on a number of growers, they are down in the mouth and see nothing but gloom and despair ahead. For them, the goose hangs low. It was my good fortune to have my beds snugly sheltered in the valley under the hill like a hen covers her brood." (Courtesy of the Van Dillon Collection.)

The Acquackanonk Grange Hall was dedicated on the western end of Van Houten Avenue on February 21, 1912. By 1944, it was rented and, in 1952, it was sold to the Clifton Masonic Temple Association. (Courtesy of the Van Dillon Collection.)

The homestead of Scwindenhamer Farm stood on the southwest corner of Grove Street and Van Houten Avenue. This scene appears on a *c.* 1912 postcard. The red barn and main house stood until the 1990s, when they were razed for a condominium development called Grove Estates. (Courtesy of the Clifton Public Library.)

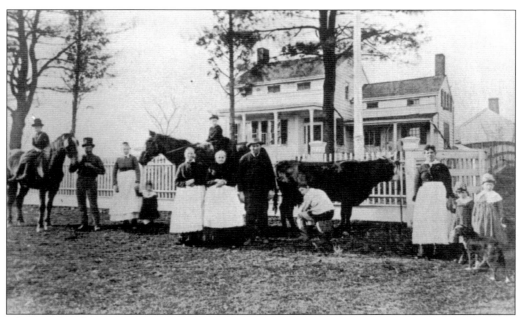

The Lotz farmhouse on Grove Street, once known as Telegraph Road, still stands today and was a neighbor of the Smith Farm, whose descendants still reside along that section of Grove with magnificent views of the Manhattan skyline. (Courtesy of the Clifton Public Library.)

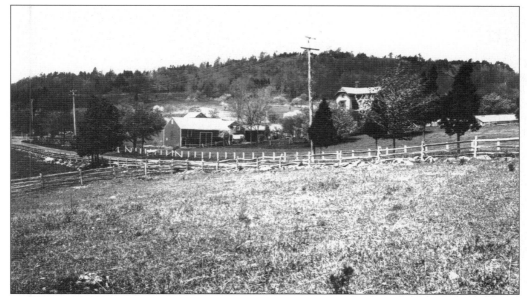

The Piaget farm was part of the family presence in what was to become Clifton. Henry F. Piaget purchased the inn at Great Notch *c.* 1839 and ran a tavern and large farm. He quit the tavern business, turning it over to his son Frank Piaget *c.* 1852. Later, son Francis H. Piaget, who at the time was a farmer and lived near the tavern, took over until the property left the family's hands in 1897. The farm encompassed some 30 acres. (Courtesy of the Passaic County Historical Society.)

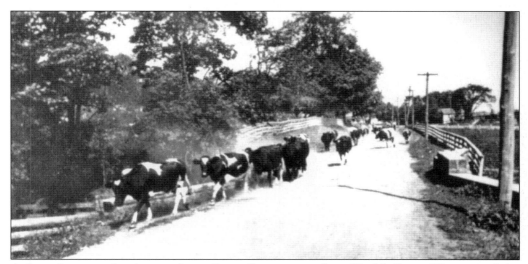

A line of cows makes its way down Grove Street across from Ploch's Farm. (Courtesy of the Clifton Public Library.)

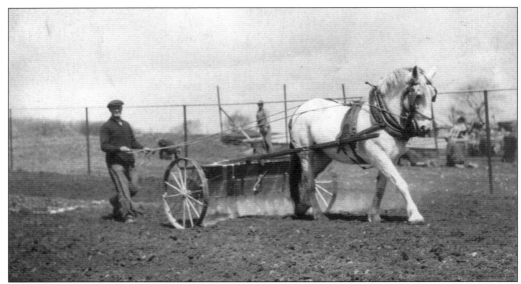

Jacob Ploch (above) works with a horse-drawn plow on the farm, fronting Grove Street. On the same farm in April 1932, Rudolph Ploch (below) uses a gas-powered plow. Today, Rudolph's son, Rudy Ploch, works the crops much as his father did 70 years before. A shed on the property, which houses his father's old truck with the marking "Rudolph Ploch and Son," was made with wood boards from an old church that was dismantled in Paterson c. 1900. The property was established as a dairy farm in 1867 by Rudy's great-grandfather George. (Courtesy of the Ploch family.)

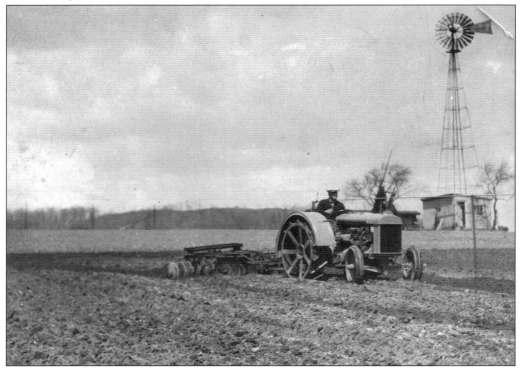

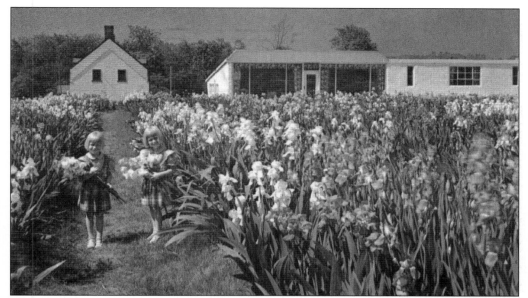

The message on the back of this 1952 postcard says "Selling out! Iris clumps in flower. Also daylilies at bargain prices." The scene is Wittman's Iris Garden, at 1435 Van Houten Avenue off Route 6 (now Route 46). (Courtesy of the Mark S. Auerbach Collection.)

Broad Acres was built in the early 1930s by C.J. Benkendorf and was run for a time by his children. It still stands near the intersection of Broad and Grove Streets and today is home to Dundee Tile. (Courtesy of the Van Dillon Collection.)

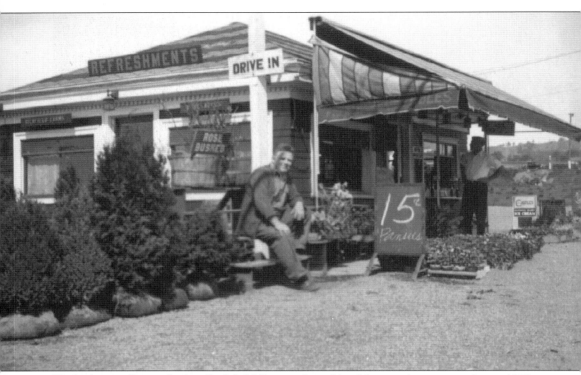

"Refreshments" were had at Richfield Farms, along Van Houten Avenue, in this *c.* 1920 view of the roadside stand before the creation of its distinctive "Richfield Farms" sign. The farm stand has been on the site, which now borders the Garden State Parkway, since *c.* 1917. Today, the family continues to serve hot cider to customers on cold winter days. (Courtesy of Richfield Farms.)

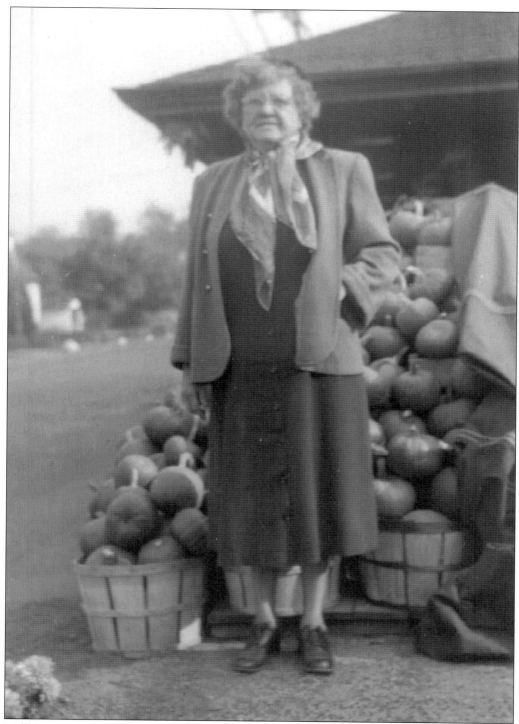

Nell Schroeder, said to be the "woman who started it all," stands amid the pumpkins at Richfield Farms. Notice the famous "hen" in the background.

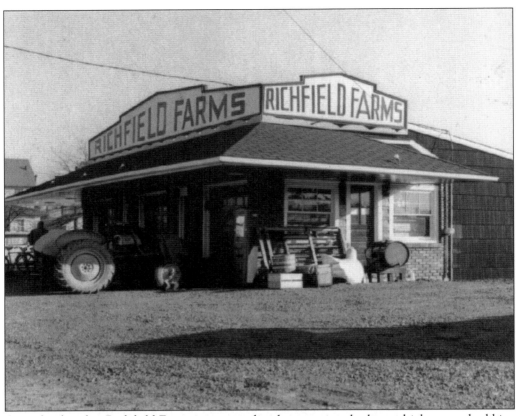

Over the decades, Richfield Farms entertained with its ponies, donkeys, chickens, and rabbits. In the back of the property today sits an old gas station (above) that was once by the roadway. It now provides periodic shelter for the donkeys. (Courtesy of Richfield Farms.)

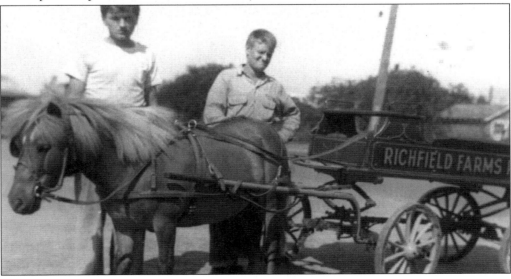

It was called "the pony track." Six rides could be had for 25¢. Carl L. Schroeder (top center) started the fun at Richfield farms *c.* 1934. When he was nine years old, Schroeder had one pony. He soon acquired two more for the track. The rides ended by World War II, but animals of various kinds are still kept on the family farm of Schroeder's daughter Debbie Schroeder Morton and Jack Morton. (Courtesy of Richfield Farms.)

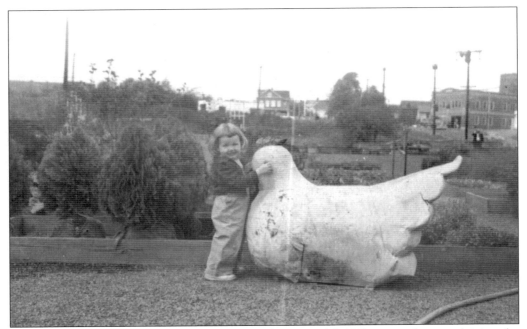

Vegetables were piled high (below) in the early days at Richfield Farms, perhaps explaining the size of the "hen" with Barbara Schrone (above), a cousin of the Schroeder family. This 1950s-era picture was taken before the Garden State Parkway cut through to the west side of the property. The firehouse at Broad Street and Van Houten, seen on the right, is still in use today. The hen was eventually stolen. (Courtesy of Richfield Farms.)

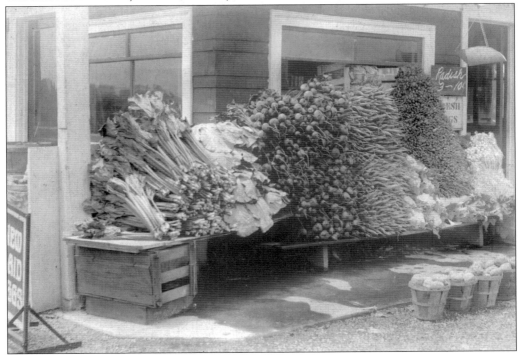

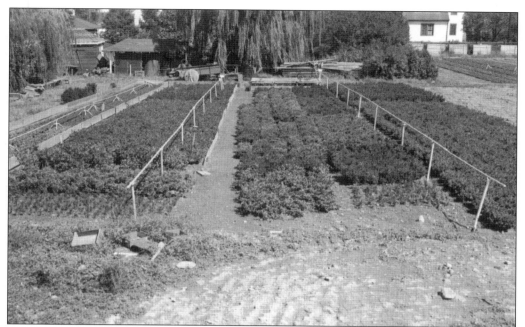

A large crop of azaleas was once harvested on the field behind Richfield Farms. (Courtesy of Richfield Farms.)

Hamersma's Dairy covered about 20 acres and reached from the top of Mount Prospect Avenue toward Garret Mountain. The house and barns were demolished to make room for a housing development, now accessible from Clifton Avenue Extension at St. James Place. (Courtesy of the Van Dillon Collection.)

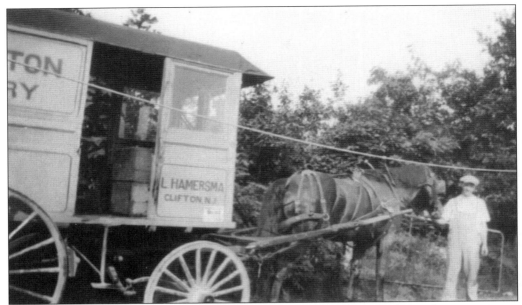

Hamersma's Dairy, established by Louis P. Hamersma, originally used a horse-drawn wagon, as shown above *c.* 1918. Later, the dairy used the truck seen below, outside the brownstone farmhouse built in 1899 and purchased *c.* 1915 by Louis P. Hamersma. The farm was operated by business partners Peter Hamersma and George Van Althuis. The property was sold in 1953. (Courtesy of the Van Dillon Collection.)

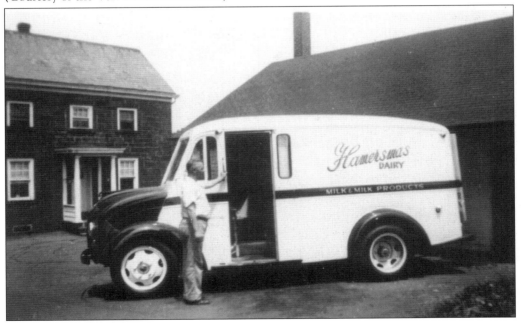

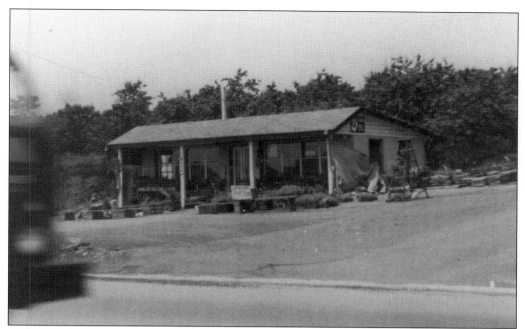

As late as the 1970s, Ploch's Farm & Nursery, on Broad Street and Allwood Road, was largely a fruit-and-vegetable stand, where a small bag of peanuts could be purchased by local boys. The nursery was still run by the Ploch family when the *c.* 1950 photograph above was taken. In 1976, George and Pauline Ploch sold the stand to Joseph W. Spirko, who kept the well-known Ploch name. (Courtesy of Ploch's Garden Center.)

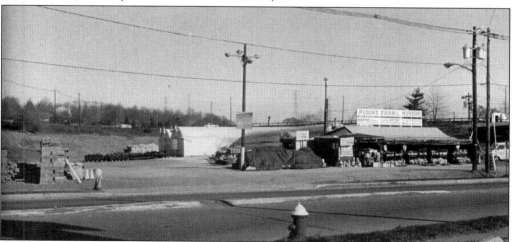

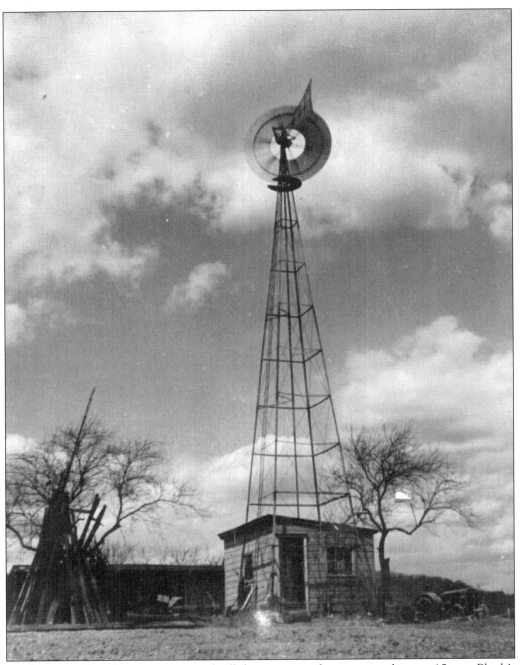

It is long gone, but the impressive windmill that once stood sentry over the now 15-acre Ploch's Farm on Grove Street is fondly remembered by family members, who still work the land and the seasonal farm stand. About 80 percent of what the family grows is sold at the farm stand, a 3,500-square-foot retail establishment. The remaining 20 percent is sold to wholesalers and restaurants. (Courtesy of the Ploch family.)